Rembrandt
Masterpieces of Art

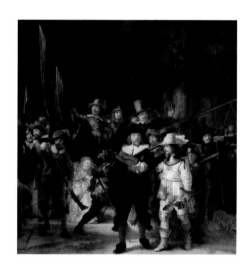

Publisher and Creative Director: Nick Wells
Commissioning Editor: Polly Prior
Senior Project Editor: Catherine Taylor
Picture Research: Jérémie Lebaudy
Art Director and Layout Design: Mike Spender
Copy Editor: Daniela Nava
Proofreader: Dawn Laker
Special thanks to: Josie Mitchell and Jane Ashley

FLAME TREE PUBLISHING
6 Melbray Mews
Fulham, London SW6 3NS
United Kingdom

www.flametreepublishing.com

First published 2016

16 18 20 19 17
1 3 5 7 9 10 8 6 4 2

© 2016 Flame Tree Publishing Ltd

A CIP record for this book is available from the British Library upon request.

Image credits: © **Bridgeman Images** and the following: 1 & 63, 20, 49, 54, 62, 75, 97, 119 Rijksmuseum, Amsterdam, The Netherlands; 3 & 91, 94 Gemaeldegalerie Alte Meister,
Dresden, Germany/© Staatliche Kunstsammlungen Dresden; 4, 31 Collection of the Earl of Pembroke, Wilton House, Wilts.; 6, 30, 50, 92 Mauritshuis, The Hague, The Netherlands;
7, 41 Gemaeldegalerie, Berlin, Germany/De Agostini Picture Library/G. Dagli Orti; 8, 80–81 Museum of Fine Arts, Boston, Massachusetts, USA/Zoe Oliver Sherman Collection/Given
in memory of Lillie Oliver Poor; 9, 105 The Barber Institute of Fine Arts, University of Birmingham; 10, 53 Kunstmuseum, Basel, Switzerland; 11, 52 Musee des Beaux-Arts, Lyon,
France; 12, 83 Germanisches Nationalmuseum, Nuremberg, Germany; 13, 18, 22, 35, 68–69, 72, 88, 93 Gemaeldegalerie Alte Meister, Kassel, Germany /© Museumslandschaft
Hessen Kassel/Ute Brunzel; 14, 26, 38, 56, 65, 77 Hermitage, St. Petersburg, Russia; 16, 86 Musee de la Ville de Paris, Musee du P etit-Palais, France; 17, 99 The Iveagh Bequest,
Kenwood House, London, UK/© Historic England; 19, 104 Ashmolean Museum, University of Oxford, UK; 21, 45 National Gallery, London, UK; 23, 106 Private Collection/Photo
© Christie's Images; 24, 122, 125 Hamburger Kunsthalle, Hamburg, Germany; 25, 76 Nationalmuseum, Stockholm, Sweden; 27, 112 UCL Art Museum, University College London,
UK; 29, 37 Prado, Madrid, Spain; 33 Rijksmuseum, Amsterdam, The Netherlands/© Leemage; 34 Metropolitan Museum of Art, New York, USA/Artothek; 36, 85 Alte Pinakothek,
Munich, Germany; 39 Royal Castle, Warsaw, Poland; 42, 67, 95 National Gallery of Art, Washington DC, USA; 44, 55, 70, 124 Louvre, Paris, France; 48 Norton Simon Collection,
Pasadena, CA, USA; 59, 84 Isabella Stewart Gardner Museum, Boston, MA, USA; 60–61, 101 National Gallery, London, UK; 74 Gemaeldegalerie, Berlin, Germany; 82 J. Paul Getty
Museum, Los Angeles, USA; 87 Gemaeldegalerie, Berlin, Germany/Photo © Tarker; 89 Museu de Arte, Sao Paulo, Brazil; 90 Buckland Abbey, Devon, UK/National Trust Photographic
Library; 100 Wallraf-Richartz Museum, Cologne, Germany; 107 Graphische Sammlung Albertina, Vienna, Austria; 108 Musee Bonnat, Bayonne, France; 109 Museum of Fine Arts,
Boston, Massachusetts, USA/John H. and Ernestine A. Payne Fund; 110, 117 Private Collection; 111 Pushkin Museum, Moscow, Russia/© FineArtImages/Leemage; 113 Museum
of Fine Arts, Boston, Massachusetts, USA/Harvey D. Parker Collection; 114–115, 116, 118 Fitzwilliam Museum, University of Cambridge, UK; 120 Leeds Museums and Galleries
(Leeds Art Gallery) UK; 121 British Museum, London, UK; 123 Chatsworth House, Derbyshire, UK/© Devonshire Collection, Chatsworth/Reproduced by permission of Chatsworth
Settlement Trustees. © **Artothek** and the following: 43, 46, 47, 73; 40, 57 Hans Hinz; 64, 71, 96 Peter Willi; 66 Joseph S. Martin; 98 Paolo Tosi. © **AKG Images**/André Held: 15, 58.
© **Mary Evans Picture Library**/Imagno: 32.

ISBN 978-1-78361-908-5

Printed in China | Created, Developed & Produced in the United Kingdom

Rembrandt
Masterpieces of Art

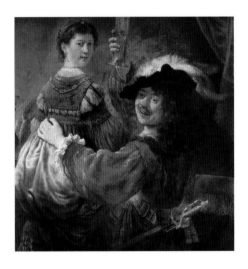

Susan Grange

FLAME TREE
PUBLISHING

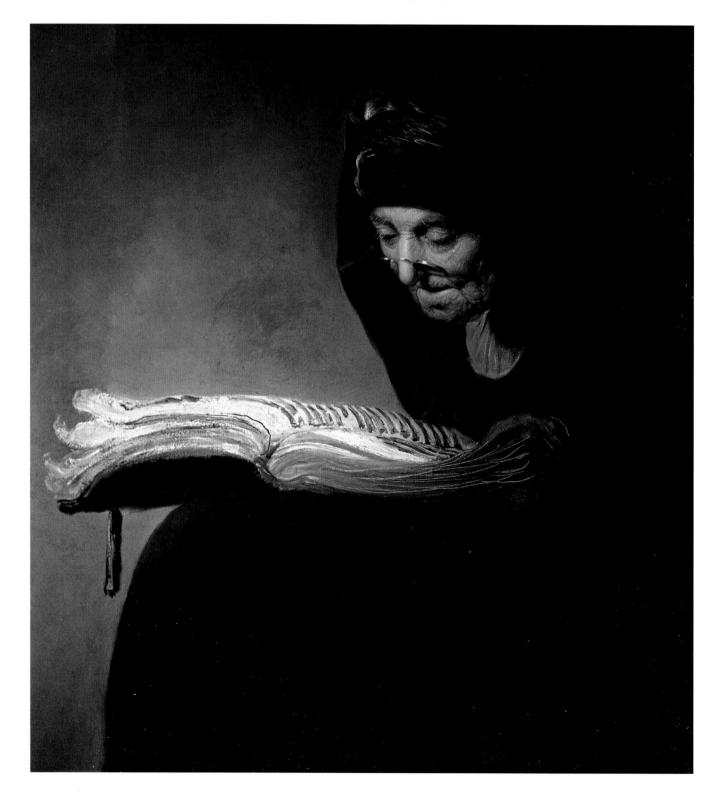

Contents

Rembrandt: Artistic Giant of the Dutch Golden Age

Rembrandt Harmenszoon van Rijn (1606–69) is considered to be the leading Dutch painter and graphic artist of the seventeenth century, also known as the 'Golden Age of Dutch Art', and one of the greatest artistic European masters. His prolific output of creative work, which includes paintings, drawings and prints, is characterized by its variety of subject matter, psychological depth and originality. His subjects range from personal and group portraits to the depiction of mythological episodes, and from landscape drawings to striking interpretations of biblical events and themes that earned him recognition as one of the greatest art historical interpreters of the Bible. The large number of self-portraits which he produced provide a window on the changing periods of his life, the effects of the passing of time, and the opportunity to plumb the depths of self, of human expression and the inner life.

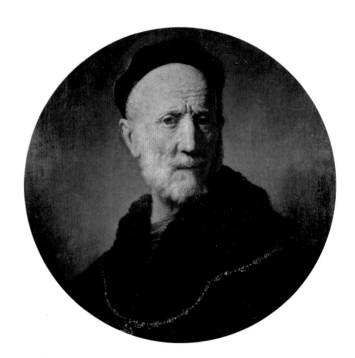

Family

Rembrandt was one of the youngest in the family of nine, possibly ten, children born to the miller Harmen van Rijn (c.1568–1630) and his wife Cornelia (1568–1640), the daughter of a baker. Harmen's windmill was on the banks of a branch of the river Rhine and so he became known as 'van Rijn' (of the Rhine). Although his name sounds almost aristocratic, the family background was firmly working-class; it is known that one of his brothers became a miller and another a cobbler, and it is thought that all his brothers and sisters remained in Leiden. Rembrandt would take the people around him as models for his pieces and it has been suggested that some of his works include studies of his parents, and possibly his brothers and sisters. By the time he was born, his parents had been married for 17 years and possible depictions of them show them as old people (*see* pages 30 and 31).

Leiden

Harmen's windmill was in the northern district of the town of Leiden, near to its medieval walls. In the year when Rembrandt was born, the population of this prosperous town, situated close to the sea and around 40 kilometres from Amsterdam, was around 17,000; by 1625, it was estimated to be around 45,000. The main industry was that of textiles, particularly the production of Leiden broadcloth, which led to the town becoming second in size only to Amsterdam. It was also wellknown for its trade in printing, publishing and selling books – a trade connected with its distinguished university, which had been founded in 1575. In the sixteenth century, a renowned art movement had developed in Leiden. Its most famous artist was Lucas van

Leyden (*c.* 1494–1533) who was also, as Rembrandt was to become, an accomplished engraver. His work, which was based on religious themes, with characters and subjects drawn from contemporary life, involved intricate attention to detail, leading to what became known as 'fine painting'. Rembrandt owned a collection of van Leyden's prints.

A New Nation

The seven Protestant United Provinces of the northern Low Countries (now called the Netherlands) had broken away, after a long and hard war, from the southern Catholic provinces (now called Belgium). They had thrown off the yoke of Spanish rule and had gained their independence, tacitly recognized by the Spanish in 1608 but not officially ratified until 1648. This new nation, with its flat landscapes, canals and windmills, quickly grew into a powerful economic force with a strong sense of national pride. Holland was only one of the northern provinces, but the Dutch language was widely promoted to achieve linguistic unity. Protestant teachings based on the works of John Calvin (1509–64) tolerated Jewish and Catholic minorities, the family was respected and upheld, and the new prosperity was celebrated. Although each province had its rulers, there was no monarchy or aristocracy and, with no ecclesiastical hierarchy, this new Dutch Republic had no need of altarpieces, religious frescos or sculptures, as the pulpit where God's Word was taught became the focal point of church buildings. In spite of hostilities with Spain rumbling on, the nation continued to prosper and its artists provided it with works of art which reflected life in this new republic. They adapted to the new era by painting portraits, landscapes, still-life works and pictures of everyday life, known as genre paintings. Regular markets and art fairs offered paintings and prints, etchings and drawings for the local population with money to spend and who wished to embellish their houses with works of art. Also, larger civic commissions were available for the decoration of municipal buildings and meeting rooms of civic groups.

Early Life

Documentation regarding Rembrandt is surprisingly sparse: papers belonging to him amount to seven business letters, and contemporary accounts of his life and his early biographers are considered at times

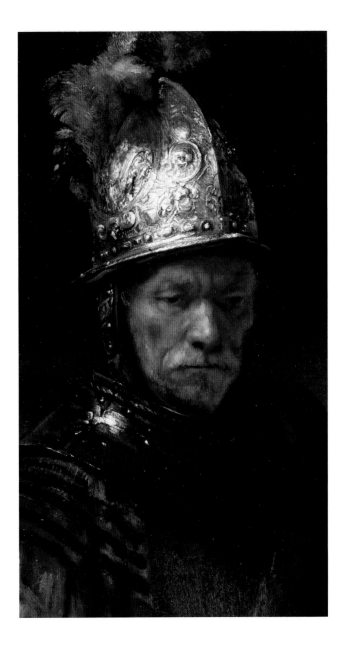

to be misleading; even the actual date of his birth is not known for certain. His biographer Jan Janszoon Orlers (1570–1646) tells us that Rembrandt attended the Latin school in Leiden, thus indicating that his parents were able to afford his education, whereas many children of the time had no formal schooling. Although he could not be described as an intellectual, Rembrandt would have studied the classics at school; he clearly had a great respect for books and

the written word, as shown in many of his artworks. It seems that his parents were keen for him to enter one of the professions, as at around the age of 14, on 20 May 1620, Rembrandt was registered at the University of Leiden to study literature. His university studies, however, were short-lived. It seems that Rembrandt wanted to develop his artistic skills and begin a career as an artist, and he managed to persuade his parents of the suitability of this course of action. They agreed to let him leave university and apprenticed him initially to an unknown painter and then to the Leiden-born artist Jacob van Swanenburgh (1571–1638).

Artistic Apprenticeship

The van Swanenburghs were an artistic family, with Jacob's father and brothers all involved in the art world. After being trained in his father's workshop, Jacob had travelled to Italy and in Naples had married an Italian. He lived in Italy for 25 years but then returned to Leiden and set up a workshop. His works concentrated frequently on scenes of hell and damnation, including strange visions and dramas, and Rembrandt seems to have been able to learn very little stylistically from him. Willem Isaacs (1580–1612) – one of Jacob's

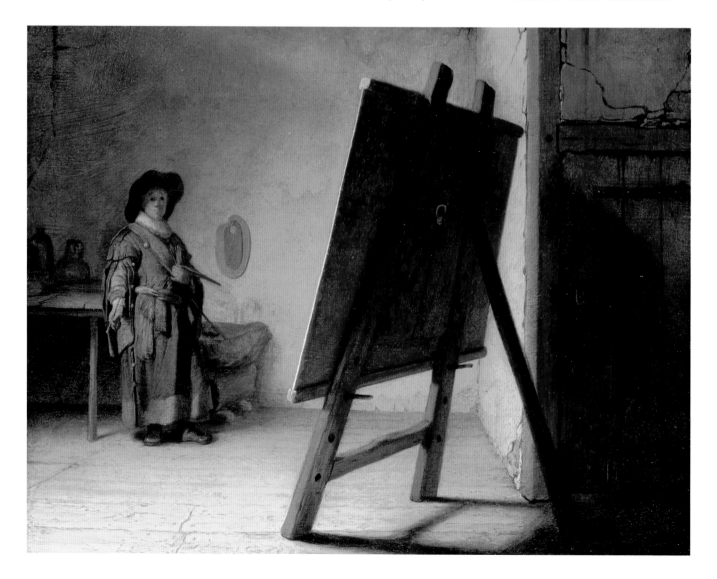

brothers – was an engraver who had been employed by the great
painter from the southern provinces Peter Paul Rubens (1577–1640)
to engrave his works; this family contact may have been instrumental
in leading Rembrandt into the appreciation and detailed study of
Rubens' works, which were to be influential in the early part of his
career. In van Swanenburgh's workshop, Rembrandt would have
learned how to grind pigments and mix colours, and how to prepare
and prime canvases and wooden panels for painting; he would also
have practised drawing with pencil, ink and charcoal. The study of still-
life arrangements and drawing the human figure would also have been
part of his training, as well as studying the works of other artists. As he
became more experienced, the apprentice would have been allowed to
finish sections of the master's work and also produce some of his own
unsigned works. While still an apprentice, though, he would not have
been allowed to sell any of his own pieces, which was something that
his master, on the other hand, could do.

Final Training

Rembrandt completed his artistic training with a move to Amsterdam
to work in the studio of Pieter Lastman (c. 1583–1633). Although
he only stayed for six months, the high quality of Lastman's work
strongly influenced Rembrandt's style and technique. Lastman was
a historical painter, producing works based on classical mythology
and religious scenes for his discerning, wealthy clients in Amsterdam.
He had travelled widely in Italy and had been inspired by Venetian
artists, and in particular by the Roman style of painting of the early
seventeenth century. Nowadays, his style is often considered serious
and at times somewhat dull but it was appealing to a certain sector
of the Amsterdam public, who were inspired by all things Italian. The
works of Michelangelo Merisi Caravaggio (1571–1610), which were on
display in Rome, had deeply influenced Lastman and indeed many of
the practising artists of the time – in particular, his use of *chiaroscuro*:
the dramatic contrasting use of light and shade that created
astonishing effects with colour and animation. During Lastman's stay
in Rome, a group of artists known as the *Caravaggisti* were striving
to develop this effect in their works. Although Lastman is not known
to have been in this group, he is considered to have been influenced
by the work of the German artist Adam Elsheimer (1578–1610), who

was living in Rome at this time and had been able to transfer the use
of *chiaroscuro* from the large, dramatic works of Caravaggio to smaller-
scale pieces and even to landscapes. In 1607, Lastman had returned
to Amsterdam, bringing with him his new-found skills, and was able
to develop a very successful practice. During his time in Lastman's
workshop, Rembrandt benefited from his teaching of this *chiaroscuro*
technique and used it to great effect throughout his career.

First Studio

Leaving Lastman's studio after only six months meant that Rembrandt
didn't have to pay the fees for the Amsterdam guild of artists. By 1625,
he had returned home to live with his parents and then it is believed

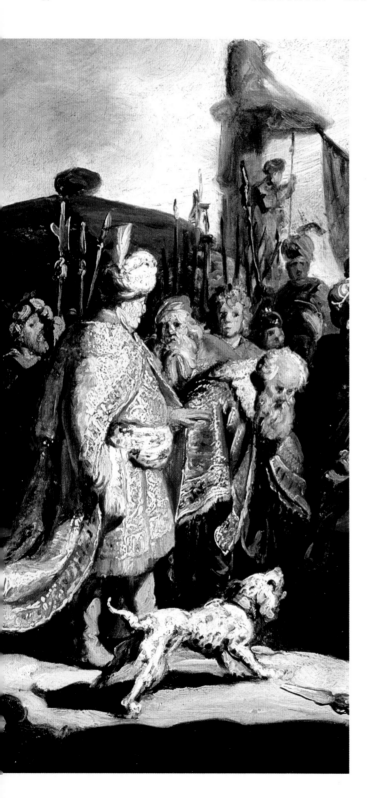

that he probably set up a studio with another up-and-coming young artist from Leiden, Jan Lievens (1607–74). Sharing of studios was forbidden by the guild of artists but this did not operate in Leiden at this time so the two young painters were able to economize on their professional expenses. Lievens had been a very precocious child and, according to one source, had been apprenticed to an artist at the age of eight, such was his evident talent. He was a year younger than Rembrandt and had also studied with Lastman, but for the longer period of two years. Having trained with the same master may have given them much common ground and also a similar direction in their creations. Many of their works from this period have been confused; they used the same models, painted similar subjects, created portraits of one another, and seemingly encouraged and spurred each other on in a spirit of lively creativity and competition.

Early Work

The Stoning of St Stephen (1625, *see* right and page 52) is the first work that has been attributed to Rembrandt with certainty. It is a medium-sized oil painting on panel based on the biblical narrative in Acts V11:54, and is dated and signed 'R f'; this stands for the Latin *Rembrandt fecit*, which means 'Rembrandt did this'. In its elegant and precious effects, interpreters have seen the influence of the earlier Leiden school of art. However, the rendering of the faces in a more classical style and the drama of the moment both reflect the works of Lastman and Elsheimer. *David Offering the Head of Goliath to King Saul* (1627, *see* left and page 53) blends the detail of Lucas van Leyden's intricate engravings, whilst evoking the richness and splendour of Venetian sixteenth-century painting. Shimmering light sparkling on the golden fabric creates a sumptuous atmosphere for the rendering of this biblical scene. Early self-portraits include *Artist in His Studio* (*c.* 1627–28, *see* pages 80–81), which gives the viewer something of a declaration of Rembrandt's perception of his calling as an artist. Professor Simon Schama (b. 1945) considers that nothing else like this existed at the time, and that Rembrandt has created a personification of painting itself and has disappeared into his persona as an artist. It is certainly a bold proclamation not just of the practicalities of his trade, represented by the spare palette hanging on the wall and bottles of oil and varnish on the table, but also of his vocation and talent.

Increasing Recognition

Rembrandt was becoming known as a highly talented artist of standing. In around 1628, some of his works began to sell: a lawyer in Utrecht bought a painting for 29 guilders and another painting sold in Amsterdam for 100 guilders. A humanist and scholar, Arnold van Buchel (1565–1641), visited Leiden and wrote in his diary that there was a miller's son whose artwork was causing a sensation. At around this time, Rembrandt took on his first pupil: Gerrit Dou (1613–75), who was almost 15 years old. This event signalled an improvement in Rembrandt's finances, as he would have been paid to train Dou, and also a big step forward in Rembrandt's career. Dou was from Leiden, the son of a glass engraver who had been taught by his father, with input from other glass painters and engravers. He was a talented artist who worked with great style and skill. Dou stayed in Rembrandt's workshop until the latter moved to Amsterdam in 1632, and he went on to be a master in his own right and one of

the most representative figures of the Leiden school of fine painters. He specialized in creating small paintings executed with flawless skill and fine, delicate detail. These works were much in demand and he became very successful. His training with Rembrandt was vital to his development as an artist; he was able to absorb Rembrandt's methods and techniques, and he developed them to create his own style. He also took on a civic role in his hometown when he went on to found a guild of painters in Leiden in 1648.

Constantijn Huygens

Constantijn Huygens (1596–1687) was secretary to Prince Frederik Hendrik of Orange, the governor of five Dutch provinces. He was one of the most influential figures in Holland; highly educated and cultured, with a wide knowledge of both the arts and sciences, he was a very experienced diplomat, much travelled and also involved in literary work as a translator and poet. He may have thought that as the Catholic

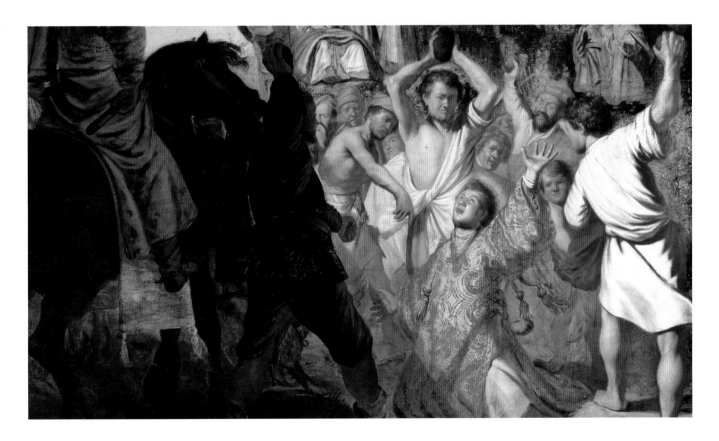

southern provinces still under Spanish rule had their great artist – the mighty Rubens – why shouldn't the Protestant northern provinces have their own artistic greats? Therefore, in his travels around the country, Huygens was on the lookout for such talented individuals. Clearly, he must have heard that something was happening in Leiden, for he wrote in his autobiography, published in 1631, of his visit in 1628 to two virtually unknown young artists there. Deeply impressed by Rembrandt and Lievens, he commented that he thought the former was 'superior to Lievens in his sure touch and liveliness of emotions'. However, he considered Lievens to have 'the greater inventiveness'. He then compared Rembrandt to famous artists of antiquity who, he said, wouldn't believe 'that which a youth, a born and bred Dutchman, a miller, a smooth-faced boy, has done', adding that all this has been

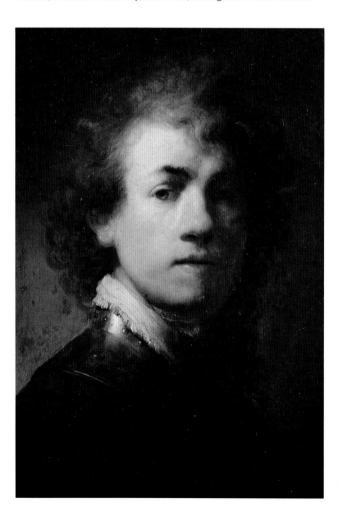

stated in dumb amazement. For both Lievens and Rembrandt this was a defining moment in their careers. Huygens commissioned the former to paint his portrait and Rembrandt to paint his brother's. He closely followed the careers of both artists, obtaining commissions from the Prince for Rembrandt and helping Lievens when he moved to England. In some aspects Huygens acted as an unofficial agent for the two, promoting their works to international collectors.

A Business Proposition

With an increasingly high profile and burgeoning economic success, Rembrandt was looking to develop his career further. After meeting an art dealer from Amsterdam, Hendrick van Uylenburgh (c. 1587–1661), Rembrandt made the decision to move to Amsterdam. Van Uylenburgh had many contacts and wealthy clients who were particularly interested in having their portraits painted. He offered Rembrandt a very advantageous arrangement in which he provided lodgings and a studio for him, while also acting as an intermediary between the artist and his clients. Van Uylenburgh would handle the business side of things and Rembrandt would be in control of the painting, the studio and assistants. This meant that for a time Rembrandt would have to concentrate on painting the rich and famous art collectors of Amsterdam so that his name would become known and his client base expand. In 1632, Rembrandt moved to Amsterdam for good, and he and van Uylenburgh effectively became business partners. The arrangement worked very well for both parties, with the well-run enterprise leading to demand for artworks and thus creating economic success. The workshop size increased and Rembrandt still continued to teach, organizing an art school mainly for the sons of some of his wealthy clients.

Amsterdam

Rembrandt moved to Amsterdam in the full flowering of its economic prosperity. This capital of an expanding colonial empire had around 150,000 inhabitants and was growing rapidly. From being a provincial Dutch town, it had quickly developed into the major port of northern Europe, taking over from Antwerp. Full of merchants from many different countries, its port was crowded with trading ships, and

the vast array of goods on offer in the shops and the markets was unequalled anywhere else in Europe. As well as its position as a rich merchant city dominated by the powerful East and West India companies, it was developing into a centre for learning and culture, thanks to the foundations for its university being put in place in 1632. Rapid building and urban development were taking place; three concentric canals were created, flowing through the historic centre. Attractive stone-and-brick townhouses with characteristic Dutch gables were built alongside these waterways for the wealthy merchants and members of the professional classes, and new churches and the Stock Exchange were built in Baroque style. When it came to painting, Lastman was still working mostly in the field of history painting with the brothers Jan Pynas (*c.* 1581–1631) and Jacob Pynas (*c.* 1592–after 1650), producing religious and mythological works. The two most popular portrait painters were Nicolaes Eliasz. Pickenoy (*c.* 1588–*c.* 1655) and Thomas de Keyser (*c.* 1596–1667), who were producing reliable, solid images of the Amsterdam elite. There was certainly room for an up-and-coming young and talented addition to this circle of artists and in 1632 Rembrandt was regarded as a significant figure in the city. He gave his clients of this new period in Amsterdam some verve and panache, embellishing their sombre black with lace, bows, feathers, amazing ruffs and puffed sleeves – his 1634 portraits of Maarten Soolmans and Oopjen Coppit are good examples. By experimenting with such original and dynamic poses as the 1633 *Portrait of a Man Rising from a Chair*, he pushed the boundaries of the established rules of portraiture. A number of his clients became admirers and friends, although within the next 15 years, some would turn into his creditors.

Saskia

While working with van Uylenburgh, Rembrandt was introduced to his close relative Saskia van Uylenburgh (1612–42). Her father had been burgomaster in the province of Friesland and was one of the founders of the second university of the Netherlands, in Franeker in 1585. She was the youngest of eight children from a Calvinist family. Since her mother died when she was six and her father when she was 12, she had gone to live with her older sister and her husband, who was a lawyer and town clerk. The young artist and Saskia fell in love,

but met with some disapproval from her family. However, the couple became engaged in June 1633 and in order to mark the occasion, Rembrandt drew a celebratory picture: *Saskia in a Straw Hat*. Next to the drawing, he wrote: 'This is a portrait of my fiancée at the age of twenty-one, three days after our engagement.' Rembrandt's mother, whose official approval was needed for the match, also seemed to be hesitant about the relationship, as she delayed giving her consent

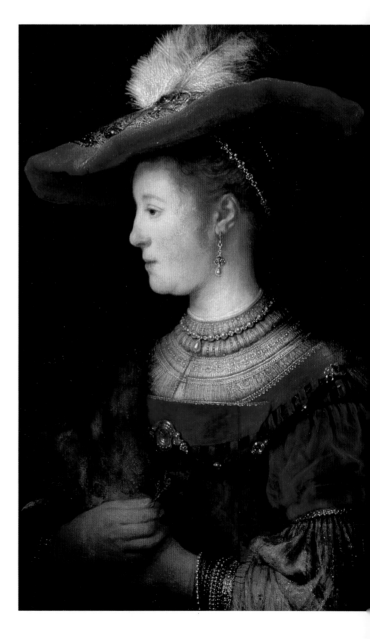

to the marriage. However, the couple tied the knot in July 1634, in Saskia's home province of Friesland, and then settled in Amsterdam, continuing the association with van Uylenburgh. The match was a good one for Rembrandt, the miller's son, as it raised his social status but his feelings for Saskia were genuine and it appears they had a loving, supportive and mutually affectionate relationship. Rembrandt was to make numerous portraits of Saskia. *Saskia as Flora* (1634, *see* page 38) shows her as a young goddess bedecked with flowers, at one with the world of nature and possibly pregnant. She did go on to have a boy in 1635, named Rombertus, probably after her father, but he died after two months. Approximately three years later she had a girl, Cornelia, but she died after two weeks. Another daughter who also died was named Cornelia and then in 1641 the couple had a son who lived to adulthood and whom they named Titus.

Burgeoning Success

Rembrandt's star was in the ascendant. His work as a portrait painter was highly successful and he was becoming increasingly well-known and wealthy. One work, *The Anatomy Lesson of Dr Nicolaes Tulp* (1632, *see* below and page 56), which was highly important in raising his profile was a painting for the Amsterdam guild of surgeons. It was probably commissioned by the surgeon Dr Nicolaes Tulp (1593–1674) and then paid for by each of the individuals depicted. It was in fact a group portrait, with every member shown individually as witness to the dissection. Dr Tulp, whose real name was Claes Nicolaes Pietersz, was from a wealthy family of cloth merchants. He went to Leiden University and then set up a medical practice in Amsterdam. He took the surname Tulp from the word for the flower 'tulip', for which

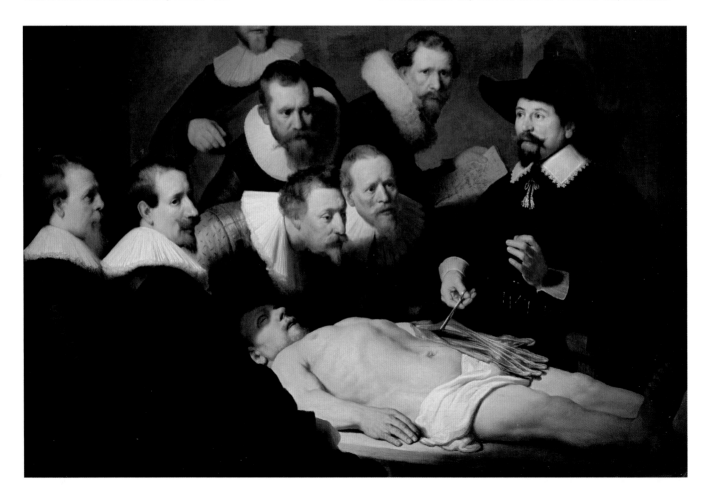

the Netherlands was famous. He became a member of the guild of surgeons and was appointed as a medical lecturer. On 31 January 1632 his lecture on dissection was opened to the public. Rembrandt's depiction of this event is recorded in this portrait, which may have been executed before the public were admitted, as generally a dissection was started by the opening up of the stomach. This work not only enhanced Rembrandt's reputation but also that of Dr Tulp, who wrote numerous medical books and also set up the first medical council in the Netherlands to regulate drugs and pharmacies. In his early work Rembrandt would often sign his pieces using simply the initials RHL. Here he has signed with only his forename, Rembrandt, as was the practice of the Italian masters, such as Titian (c. 1488/90–1576) and Michelangelo (1475–1564).

Royal Patronage

Rembrandt was one of the few Dutch artists not to have travelled to Italy to study the works of the Italian masters. Although he was encouraged to go there by a number of people, he protested that he was too busy; in fact, he barely left his home country at all. Italian works were readily available in Amsterdam; many copies and engravings were in circulation, so Rembrandt was well aware of their content and style. This lack of travel did not seem to have hindered his career. His erstwhile advocate, Constantijn Huygens, had promoted his work to Frederik Hendrik, Prince of Orange, who gave Rembrandt a commission to paint a series of paintings based on the last events of the earthly life of Christ, commonly known as 'The Passion of Christ'. The standard five works in the series are: 'The Raising of the Cross', 'The Descent from the Cross', 'The Entombment', 'The Resurrection' and 'The Ascension'. The Flemish painter Rubens had painted such a series for the cathedral in Antwerp and it seems that this was to be the Dutch Republic's grand statement on the subject. Rembrandt's series was to be smaller than that of Rubens and the measurements were carefully calculated, presumably with reference to the room in which they were to be displayed. All the works are rounded at the top, recalling the style of an altarpiece. *The Raising of the Cross* (c. 1633, *see* right and page 58) may have even been discussed with Huygens before Rembrandt left Leiden, as some drawings on this theme date from that time. The composition echoes that of Rubens'

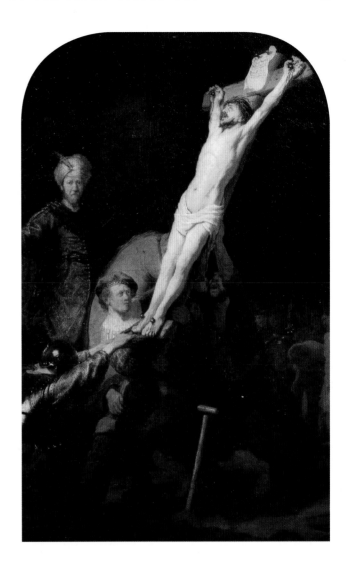

version of c. 1609–10, as does that of another painting in the series, *The Descent from the Cross* (1633). These two works were well received and the royal household commissioned the remaining three paintings. For *The Ascension* Rembrandt changed the style, possibly to please Huygens who may have encouraged him to emulate Titian's *Assumption of the Virgin* (1516–18), which he would have known from his time as a diplomat in Venice. In 1636 Rembrandt was called to the court to account for the difference in this work as compared to the first two pieces. The final two works in the series were finished in 1639 and although the royal commission was a boost to his career, Rembrandt did have some difficulties in receiving payment for these paintings.

Rembrandt's House

Rembrandt had moved often during his first 10 years in Amsterdam. Eventually, in 1639 he found a house to purchase, rather than simply to rent, which he considered appropriate for an ambitious artist of his status. He also considered it suitable for family life, as well as providing him with a studio and space for his pupils and for his increasing collection of art and artefacts. It was number 4 Jodenbreestraat, in the Jewish quarter of town and conveniently adjacent to van Uylenburgh's art gallery. This house is today the Rembrandt House Museum which, based on documentary evidence, has been recreated to give a real sense of what it would have been like in Rembrandt's time. The entrance hall and anteroom for receiving visitors are spacious, elegant and filled with paintings by artists of the period, such as Jan Pynas, Lievens, Lastman, and Rembrandt's pupils, e.g. Gerrit Dou and Ferdinand Bol (1616–80). The studio is spacious and north-facing, which allows the light to fill the room but not overpower it. On the top floor, partitions create cubicles so that students could have individual space to work at their easels. A large room gives an idea of the scope and quantity of objects, and books of prints and drawings in Rembrandt's collection. Moving to such a property made a bold statement about Rembrandt's situation and prospects, and no doubt impressed his clients and visitors, who were often potential customers. In *Self-portrait Leaning on a Stone Sill* (1639) he depicted himself as distinguished and prosperous, wearing expensive clothes made of rich fabric. The piece is a reference to a painting by Titian – *Man with a Quilted Sleeve* (1510) – and also to

a 1498 *Self-Portrait* by Albrecht Dürer (1471–1528) and a portrait by Raphael (1483–1520) of *Baldassare Castiglione* (1514–15), who was a respected writer and courtier. These references would not have been lost on Rembrandt's knowledgeable clients, who would have realized the artist's intention of showing that he was following in the footsteps of the great masters and a great master himself.

Self-portraits

Throughout his life Rembrandt painted his self-portrait; today there are over 75 still in existence in various forms, including drawings and etchings. Beginning in the 1620s, they stretch over time to the last year of his life. Initially, like many students and early independent artists, he created studies which reflect his first experiments and opportunities for skill development in portraying the human face and playing with the effects of light and shadow. Some later works can be considered as the artist trying out different ways of developing his work as a portraitist, using himself as the model rather than the client. In Rembrandt's later works they develop into genuine psychological penetrations of his emotions and state of mind. In his *Self-portrait at an Early Age* (c. 1628–29), his shock of curly hair with golden highlights on certain strands contrasts with the dark shadows which almost shade his eyes completely. Rembrandt's love of theatricality and dressing up, using his growing collection of costumes and props, led him to dress himself in a variety of guises and to portray himself as various characters; his *Self-portrait in Oriental Costume* (1631, *see* above and page 86) is a case in point. In his *Self-portrait with Cap and*

Gold Chain (1654, see page 93) the artist perhaps depicted himself as he would have liked to be seen, with the recognition of a gold chain of distinction and honour – a chain which he had not been presented with but that he probably considered he deserved. His Self-portrait as the Apostle Paul (1661, see page 97) shows him in the period after his financial insolvency. Here he is possibly proclaiming his fortitude and persistence during changing circumstances, like the mighty apostle himself, although his almost quizzical expression challenges the viewer to question whether all his efforts have really been worth it. In his Self-portrait (c. 1665 see right and page 99) he appears to be in a more positive frame of mind, showing himself dressed in a rich cloak and in a distinguished pose as he holds his palette, brushes and mahlstick. Despite the deaths of those close to him and his financial ruin, his art never let him down and had always been there for him. His Self-portrait (c. 1668, see page 100) refers to the story of the Greek painter Zeuxis, who allegedly died laughing at his own painting of an old woman. Is this Rembrandt's final joke for us? His last self-portrait of 1669 at the age of 63 (see page 101) shows us someone more contented, with a slight yet pleasing smile, and communicating a sense of serenity and dignity.

Death and Finances

At 13,000 guilders, the new house was expensive, especially when considering that the deposit of 1,200 guilders could itself have bought a smaller house outright, and running expenses were high. As Rembrandt's order book was full and he had all the right contacts and even royal patronage, he no doubt felt that he would be able to live there without any financial difficulties. It is even documented that he loaned 1,000 guilders to van Uylenburgh, although it is not known what this was in connection with. According to the arrangement, Rembrandt would initially pay a quarter of the purchase price for the house in advance and then settle the balance over the next six years. However, it is clear that Rembrandt did not prioritize paying for the house. It is recorded that, even though he lived simply, he entertained his guests well but his main priority and interest seems to have been growing his collection of busts and statues, weapons, prints and drawings, costumes, and whatever else took his interest. Many of these objects were used in his work as props but it cost a vast amount of money to develop such a collection. Unfortunately, after the birth of Titus, Saskia became increasingly weak and ill, and in 1642 she died at the age of 29, when Titus was nine months old. Her will was unusual: it prioritized Titus and also stipulated that if Rembrandt remarried, the part of their estate that was Saskia's would pass to her sister. This was to cause difficulties for Rembrandt in his personal life and also made his financial situation complicated. It is not known why Saskia made this stipulation about remarriage but she may well have assumed that Rembrandt would continue to be prosperous through his work in his own right and so would not need to rely on her wealth. Rembrandt began to take loans from friends to bridge any gaps when he was waiting for payments, while at the same time continuing to buy objects for his collection and not paying down the loan on his house. This combination of actions was to store up difficulties for the future.

Religious Works

Rembrandt was not a churchgoer and adopted an open approach
to religion, painting adherents to all the various religious groups in
the Dutch society of the time, which was no doubt a useful approach
that aided his business affairs. His father was a member of the
Dutch Reformed (Protestant) Church and, although his mother was
a Roman Catholic, she went along to her husband's church. This
undoubtedly helped Rembrandt to understand both sets of teachings
and led him to follow his mother in her devotion to the Bible. His
early work *Jeremiah Lamenting over the Destruction of Jerusalem*
(1630, *see* page 54) enabled him to play with the effects of dark
shadows, and red and gold highlights. What is possibly the glow of
Jerusalem burning emphasizes the gold tinges on precious items
and on Jeremiah's clothes. The effect of the destruction of the city
on Jeremiah is profound; his anguished face is desolate and his

body is slumped to one side. Rembrandt painted a number of works
depicting Jesus, Mary and Joseph, including scenes of the Nativity
and the flight into Egypt. He also painted portraits of a number of
protestant preachers in the Amsterdam society of the day. In a later
work, *Jacob Blessing the Sons of Joseph* (1656, *see* below and page
72), Rembrandt unusually allows himself a slight departure from the
biblical text by introducing Joseph's wife as an onlooker to the blessing,
even though she is not mentioned in the passage as being present.
She provides a compositional and psychological balance to the work.

Master Etcher

As well as being a master artist, Rembrandt was a master etcher and
has been called the greatest etcher of all time. Etchings produced
black and white scenes which could be duplicated so that the artist
was able to sell numerous copies rather than just one original work.

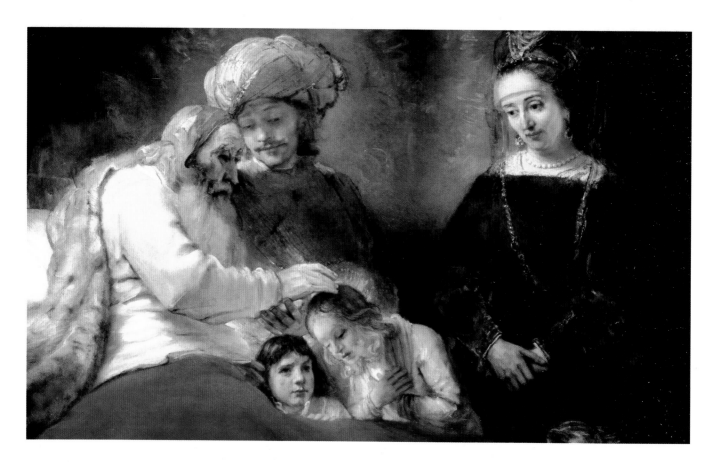

This was financially beneficial to the etcher, since he could sell more items; much of Rembrandt's income came from his etchings. His works are technically of extremely high quality and full of expression, providing the opportunity to explore the contrasts and variations between black and white, and light and shade. Lastman was an excellent etcher and so Rembrandt had had a good teacher who helped him to develop this skill. In order to create an etching, the artist would take a copper plate, cover it with a thin film of wax, take a needle or stylus and draw an image on it. The plate would then be immersed in acid, which would eat away at the scratched lines. Further lines could be scratched on the plate afterwards to create more detail in the image and the plate would be immersed in the acid again. This enabled the etcher to create darker and lighter lines, depending how long they had been in the acid. When the image was ready, ink would be pressed into the grooves formed by the lines. After the plate had been wiped clean, leaving the ink in the grooves, paper was put on top and a thick pad placed on top of that. This would then be squeezed through a roller to create a print of the image, which would finally be hung on a line to dry. Rembrandt would often make the grooved lines deeper using a drypoint needle, which gave him even more diverse effects. He also used various types of paper; Japanese paper was the best one to use, as it was strong yet delicate and produced a very clear image. He created many prints when still in Leiden, choosing a variety of subjects that included scenes of life in the Netherlands, family members, and the poor and elderly. His *Beggar Man and Beggar Woman Conversing* (1630, *see* right and page 104) is an example of this type of subject. Throughout the rest of his life he would continue to create etchings. In the Rembrandt House Museum is a room which is thought to have contained his printing press and where demonstrations of his process of etching are shown to visitors.

Guilds, Corporations and Civic Groups

Many of Rembrandt's most prestigious commissions came from associations and groups with which he had professional contacts and led to the creation of some of his finest works. Group portraits of the governors and leaders of such groups were very popular commissions for artists. Rembrandt had studied in detail copies of *The Last Supper* (1495–98) by Leonardo da Vinci (1452–1519) and this had been a

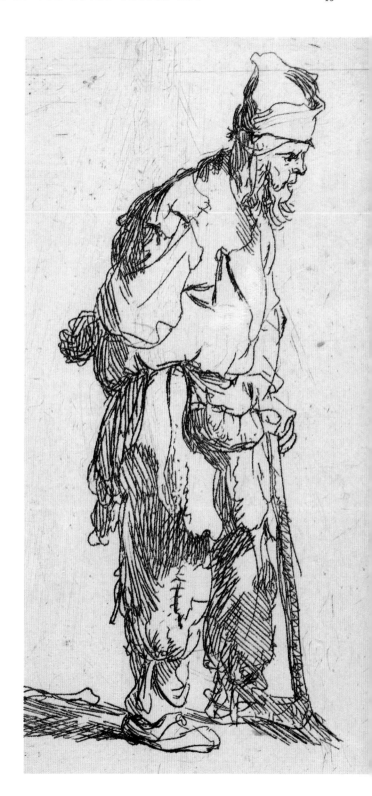

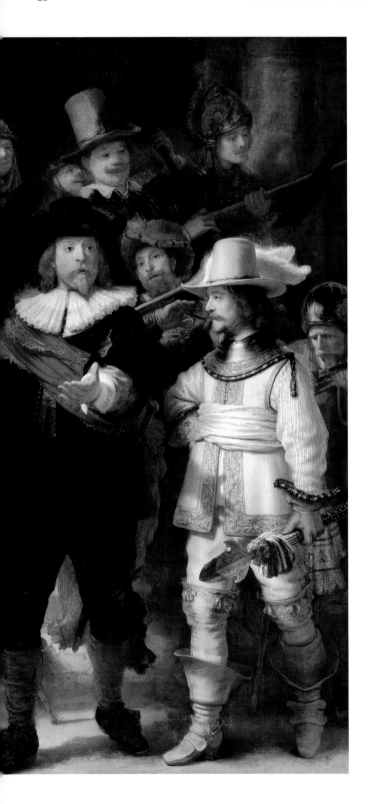

crucial step in the development of his understanding and execution of the group portrait. Guilds were associations of merchants, tradesmen or specialists in a certain skill who came together to provide support and professional protection for their members. They often had their own meeting houses, hosted banquets and put on parades. Being a governing member of such a group was a high social position that conferred prestige and often the ability to commission works of art and group portraits needed to decorate the headquarters of the group. In the 1630s a new building, the Kloveniersdolen, for the headquarters of the groups of the civic guard had been built in Amsterdam. The term 'kloveniers' comes from the title of a division of the civic guard named after their gun. Although times were now on the whole peaceful, the militia groups had retained some of their military duties, including their image as defenders of the city, even though their function had become increasingly ceremonial. On the first floor of this new building, known as the 'Great Room', was a large space intended for banquets and functions, such as receptions for Dutch and foreign visiting delegations, and royal visits. In order to decorate the building, a series of group portraits of the six civic guard companies was commissioned to a variety of artists, including two of Rembrandt's former pupils: Govaert Flinck (1615–60) and Jacob Backer (1608–51). Such a commemorative painting was usually paid for by the members of the group themselves, who each paid a sum according to where they were placed and how long the painting of their portrait took. All of them would visit the artist's studio in turn to have their likeness added to the overall ensemble.

The Night Watch

Rembrandt was given the honour of painting the company positioned by the city gates and led by its captain Frans Banning Cocq. Although the company is depicted in daylight, the work became known as *The Night Watch* (1642, *see* left and page 63), due to the heavy use of varnish which darkened the scene. This extremely prestigious and very large work was the most demanding piece of his career so far and a challenge for the artist. He rose to it by incorporating all aspects of his professional skill and training: his ability to create animated and perceptive portraits, the creation of a panoramic scene of people and place, the use of colour reflecting Venetian Renaissance painting

and the masterly use of *chiaroscuro* all work together to produce a synthesis of his abilities, expression and skill. He works within the local tradition of the group portrait but creates a completely original interpretation of it and executes it masterfully. The painting shows Captain Banning Cocq ordering his lieutenant to march the company out. This call to arms in a real-life setting, including the depictions of even dogs and children, shows the role of each participant in the company and subordinates the individual portraits to the overall animation of the ensemble, and as such was wholly original and even revolutionary. Rembrandt added some symbolic references, such as the great arch which represents the city and the young girl who has the kloveniers' emblem of claws at her waist. He portrayed the drummer who played at festive events and also depicted a variety of positions for muskets, which are thought to have been taken from arms manuals of the time. Although a pupil of Rembrandt – Samuel van Hoogstraten (1627–78) – criticized the artist for making the painting according to his own wishes rather than focusing on the portraits themselves, he conceded that Rembrandt's work 'will survive all its competitors because it is so painter-like in thought, so ingenious in the varied placement of figures and so powerful in comparison', adding that the other works in the series 'look like packs of playing cards'.

Personal Difficulties

After the death of Saskia, Rembrandt needed someone to look after his son. He chose a lady called Geertje Dircx to be Titus's nurse and also housekeeper. She was a widow from Zeeland who appears to have been efficient and sensible. She stayed in the household for seven years and it is likely that she became Rembrandt's mistress. Due to the terms of Saskia's will, it was difficult for Rembrandt to marry, as he would have lost a large portion of his estate. In 1648 Geertje made a will leaving everything to Titus so she was clearly attached to her young charge. Meanwhile, a new maid, Hendrickje Stoffels, who was 23 years old – 20 years younger than Rembrandt – joined the household. She was soon to take over from Geertje and become Rembrandt's mistress. Geertje was furious and took the artist to court for breach of promise, accusing him of reneging on a pledge to marry her. Rembrandt countersued her for supposedly trying to pawn Saskia's jewellery. Eventually, the court stipulated that Rembrandt pay her a

generous annual pension of 200 guilders a year. However, in 1650 Geertje was sent to the women's house of correction in Gouda and remained there for five years. It was rumoured that this was somehow connected to Rembrandt. All these events had a detrimental effect on the artist's affairs. He was living with Hendrickje, still spending large sums of money which he could not afford on his collection of artefacts and he did not go to any church, which was a serious misdemeanour in the eyes of the upright Calvinist society of the time. In 1654 Hendrickje and Rembrandt were summoned to the Church court to answer charges of living together without being married. The latter didn't attend the court, as he was not a churchgoer. As a result of this process, Hendrickje was not allowed to attend church on special occasions. Around this time she became pregnant with Rembrandt's child and in October 1654 gave birth to a daughter who was named Cornelia. The relationship between Rembrandt and Hendrickje appears to have been harmonious and affectionate; Rembrandt is thought to have painted her in a number of his works, including

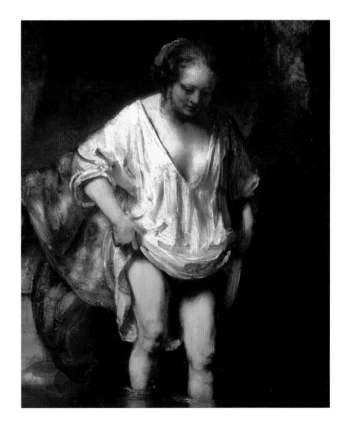

Woman Bathing in a Stream (1654 *see* page 45). All these unsavoury events led to some of his friends breaking their connection with the artist and some pupils left his school. Additionally, artistic taste was changing towards a more exuberant style and some of Rembrandt's patrons were taking their business elsewhere. Also considering the general economic depression due to the Anglo-Dutch war in 1652–54, largely over control of shipping routes in the North Sea, Rembrandt's finances were becoming seriously challenged.

Jan Six

One friend and patron who stuck by Rembrandt to begin with in these difficult times was Jan Six (1618–1700), who belonged to a wealthy family of cloth merchants. The world of commerce did not interest him and he occupied himself with collecting art, writing plays and poetry, and involvement in the life of Amsterdam, particularly in its artistic circles. In 1647 Rembrandt had created an original and striking etching of Six reading whilst leaning against a windowsill in a relaxed and informal pose. Six seems to have been pleased with the result and put other commissions Rembrandt's way. In 1654 he commissioned the artist to paint a portrait of him, which is considered to be one of his best works. Six appears serious, even sombre; he is fashionably dressed, with a red coat of rich fabric casually thrown over one shoulder, and seems to be impatiently looking at the artist. His impressive figure emerging from the dark background gives him a sense of gravitas. He is pulling on his glove as if on the point of leaving. Had Six lost patience with Rembrandt as had other friends and patrons? In 1653 Six had loaned Rembrandt 1,000 guilders, a loan which he later passed on to another party and which would be passed on again. It was widely known by then that Rembrandt was badly in debt and heading for bankruptcy. This was to be the final work commissioned from Rembrandt by Six, who chose Govaert Flinck in 1656 to paint his new bride.

Landscape and Drawings

Rembrandt produced few early landscape works but when he became a property owner, he seemed to develop more of an interest in depicting the world around him. His increasing interest in landscapes grew during Saskia's illness and after her death, so it may have

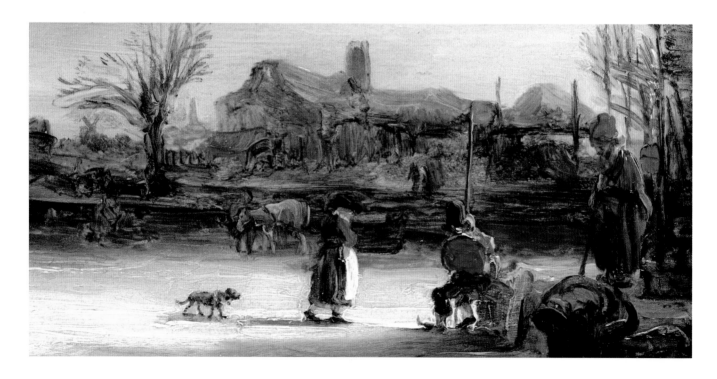

provided some consolation for him. He took as his inspiration the works of Hercules Seghers (*c*. 1589–*c*. 1638), who created imaginary mountain views, sometimes also taking real locations but adding extra features from his imagination. Rembrandt owned a number of works by Seghers and, like him, he often chose a view with which he was familiar but then embellished it with additional features. From his home he only needed to go for a short walk to see fields, trees, water, boats, houses and mills. *Landscape with a Stone Bridge* (1638, *see* page 62) is one work which can be located as a depiction of a real place. It shows a view of a tributary to the Amstel River near the Oude Kerk, in Amsterdam. Most of his other landscape works keep largely to the imaginary, with him using unusual colour effects such as dramatic *chiaroscuro*. In *Winter Landscape* (1646, *see* below and pages 68–69) he creates the atmosphere of a cold, icy day with a vast sweep of winter sky, adding figures and a dog in the foreground to create an element of human interest. In total Rembrandt painted only around 14 landscapes but he created many more using etchings and drawings. He made many drawings – at one time thought to be as many as over 1,400 – but some of these have now been attributed to his students or followers, leaving around 800 thought to be by Rembrandt himself. They cover a wide variety of subjects, from *Nude Woman with a Snake* (*c*. 1637, *see* right and page 106) to *An Elephant* (1637, *see* page 107). Unlike many of the artists of the period, he also kept a number of preparatory drawings for specific paintings.

Financial Crash

Rembrandt's financial situation continued to be in a perilous state. He was able to keep things going for a time by borrowing from friends and patrons, and even by agreeing to pay back creditors with artworks. Saskia's family worried that Rembrandt might be squandering Titus's inheritance and it was clear that he was continuing to buy works at art auctions. At one point he tried to make over ownership of his house, on which he still owed over 8,000 guilders, to Titus but this was not agreed by the authorities. Some of his customers wanted works in the more florid Baroque style, while others – possibly Jan Six among them – began to take an interest in the classical style. The economic recession compounded his difficulties and by July 1656 it had become clear that things had come to a head. Rather than declaring bankruptcy,

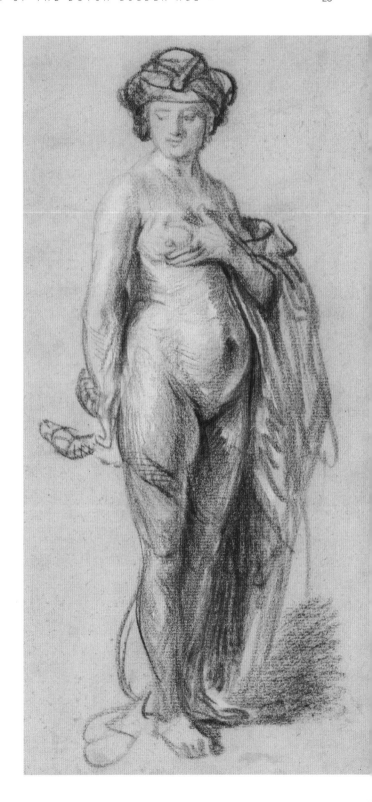

Rembrandt decided to declare himself insolvent, which gave him time to organize a sale of his possessions and to hold off his creditors, as this would limit their claims on him. It also meant that without the stigma of bankruptcy and imprisonment, he would be able to buy another property. The inventory of Rembrandt's sale of his possessions was drawn up by the Insolvency Office of Amsterdam and was taken room by room, thus making it possible to recreate the interior of the

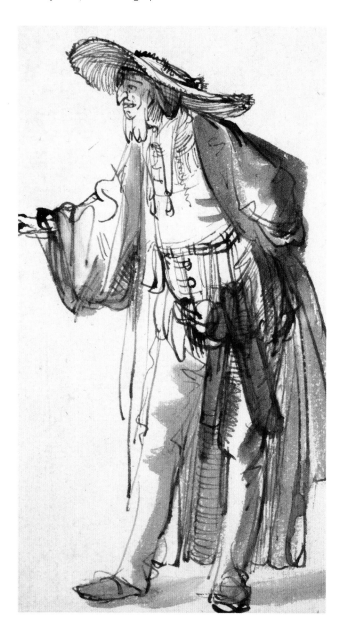

house by the Rembrandt House Museum. The inventory is of great interest because it gives details of what was in the house, including his collection of objects, artefacts, drawings and prints. He had an almost complete set of the busts of Roman emperors, plaster casts, medals and globes, weapons and armoury, Venetian glass, and musical instruments – and 25 albums contained his large collections of prints and drawings which amounted to around 14,000 sheets, of which 1,500 were the works of other artists, mostly Dutch and Italian. It is interesting to note that Rembrandt's set of etched copperplates was not included in the sale and nor were the tools of his trade and his library. It is possible that the courts took into account that he would need them to continue to earn his living so they were exempt from the sale.

New Beginning

Rembrandt and Hendrickje, with Titus and Cornelia, moved to a new, simpler house in Jordaan, on the other side of Amsterdam. This was an area, largely inhabited by artisans and shopkeepers, where people often had to focus on simply struggling by to keep going. In these humbler surroundings Rembrandt rented a house for 225 guilders a year. The regulations of the guild of artists – the Guild of St Luke, of which Rembrandt had been a member since 1634 – stipulated that no one who had been forced to sell up, whether by insolvency or bankruptcy, could continue to trade. In order to get round this, Hendrickje and Titus set up a company of which Rembrandt was an employee; he handed over to them all his new works and also acted as an 'advisor'. The company did not pay him but he received free board and lodging. This new, more settled, way of life was not to continue for long; in August 1661 Hendrickje died at the age of 37, probably killed by a plague which was particularly severe in the poorer areas of the city. Rembrandt was left with Titus and Cornelia. He continued to work but it seems that he had begun a new collection of art objects and still struggled with some debts; in 1662 he sold Saskia's grave plot in the Oude Kerk for 200 guilders. In 1668 Titus married Magdalena van Loo (1641–69) who was the niece of Saskia's sister. This union returned Titus's share of Saskia's estate to the van Uylenburgh family, thus stopping complaints from them about Rembrandt spending his son's inheritance on his art collection. The marriage was destined to be a short one, as just seven months later Titus died of plague. Magdalena

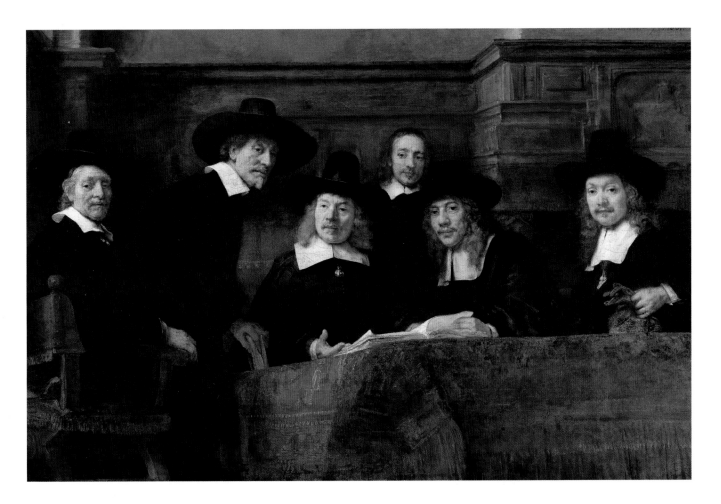

had meanwhile become pregnant and gave birth to a daughter in 1669 who was named Titia; Rembrandt was now left with his daughter Cornelia, legally illegitimate, and his new granddaughter.

Later Works

Rembrandt's reputation as a teacher ensured that he continued to have pupils up until his final years and he had not been forgotten by some of his old clients. In addition, his reputation had spread to other countries, thus creating a new demand for his works. Among the pieces he painted in later years were portraits, including group portraits, and religious and historical narrative works. One of the major commissions of this period came in 1661–62 from the group of men at the guild of drapers, which controlled the quality of cloth. In the

picture *The Sampling Officials of the Amsterdam Drapers' Guild* (1662, *see* above and page 76), five cloth inspectors are sampling swatches of cloth with a steward standing behind them. The room where the picture was to be displayed also contained group portraits of previous such groups and Rembrandt followed the same formula as these other works. However, his painting is inventive and original in concept, with one of the men shown rising from his chair; this action creates animation and movement, avoiding a static effect. An important commission was given to Rembrandt by the Amsterdam authorities in 1659. He was asked to paint *The Conspiracy of the Batavians under Claudius Civilis* (c. 1661–62, *see* page 76), one of a series of paintings shared out between several artists. Claudius Civilus was the leader of a group from the Batavi tribe who wanted to throw off Roman rule. For the united provinces this event had resonances of their own battles

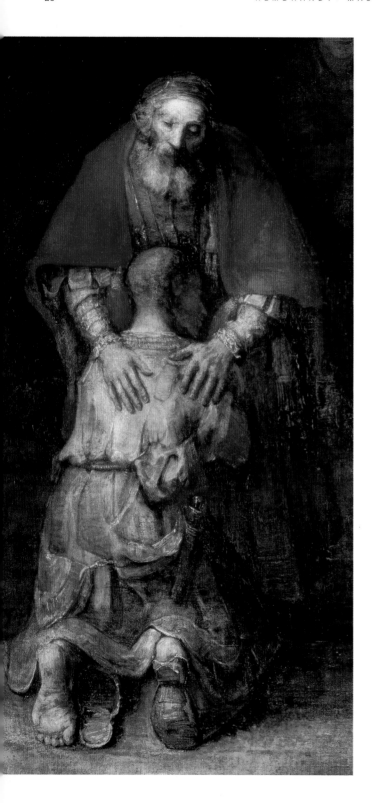

to throw off the Spanish yoke. A preparatory drawing by Rembrandt shows how the work would cover a vast area of wall when placed in its setting. The main painting which formed the central part of the scene was not received favourably by the Amsterdam authorities. Instead of a smooth, polished finish, which they may have been expecting, the work appears rough and with an unfinished effect. The scene is set at night amongst dark background shadows, with Claudius and a somewhat dubious group of rough characters glowing in a golden light. Claudius had only one eye and decorum would generally dictate that such a picture would be painted in profile. Here, however, he looks boldly out of the painting with his disability clearly visible. The authorities refused to accept the work and it is thought that Rembrandt did not get paid for it. He cut it down to a smaller size, possibly to make it easier to sell, but the whole affair did not help his reputation or his finances. A later painting *The Return of the Prodigal Son* (*c.* 1668–69, *see* left and page 77) is full of emotion and tenderness, and may have helped Rembrandt in his time of grieving for Titus. The father's face is full of compassion as he embraces his son, as if to protect him.

Techniques

Rembrandt's painting technique drew much criticism. He would build up thick layers of paint, known as *impasto*, which would create ridges that attracted the play of light. Using a palette knife, he would apply large swathes of paint and then flick them with a paintbrush or mahlstick – and even work them with his fingers. Close up this made the pictures hard to see clearly but from a distance the individual components of the work would fall into place. Gerard de Lairesse (1641–1711), a Dutch painter, wrote that Rembrandt's paint was 'like mud on the canvas'. Arnold Houbraken (1660–1719), a painter and writer, said that it looked as if he had applied the paint with a bricklayer's trowel. In his later pieces, Rembrandt referenced increasingly the works of Titian, whose late work has been said to be in his 'unfinished style'. Although the late works of both Titian and Rembrandt appear to be unfinished, one factor is that they weren't polished up and did not have finishing touches added to them to smooth out any rough edges. The thick brush strokes were allowed to be visible and colour left in blocks to make an impact.

Death and Legacy

On 8 October 1669 Rembrandt died aged 63. It is not known what was the cause of his death but he was buried in the Westerkerk in an unknown grave. Why the death of such a previously popular and well-known Amsterdam artist should pass without public recognition is uncertain. Some contemporary commentators described him as arrogant and insensitive so perhaps this had alienated him in Amsterdam society. When also considering all his personal and financial troubles, it might be possible that people had given up on him and moved on, although some friends did stick by him. His daughter Cornelia was given away at her wedding by her guardian Abraham Francen (c. 1612–after 1678), who was a friend of Rembrandt and whose portrait the artist had painted in 1656. A prolonged legal dispute followed Rembrandt's death as the result of attempts to divide his estate between Cornelia, his illegitimate daughter, and Titia, his granddaughter. There appear to have been no contemporary written accounts of Rembrandt's life, although this may be partly due to the fact that eulogies to people on their death were not encouraged in Dutch society of the time. The inventory made shortly after his death confirms that his work was sought-after, but mostly by foreign buyers. The end of the 'Dutch Golden Age' was fast approaching, as the Dutch lost out to the English at sea and in empire. Times were moving on and Rembrandt's works began to be considered old-fashioned. In the eighteenth century Sir Joshua Reynolds (1723–92) for one was inspired to emulate Rembrandt's style, but it wasn't until the nineteenth century that his work was fully reappraised, with critics declaring him to be one of the most inventive and perceptive artists to have ever lived. Today, Rembrandt's position is secure. His works are recognized as monumental landmarks in Western culture, encompassing psychological depth, emotional profundity and amazing technical skill.

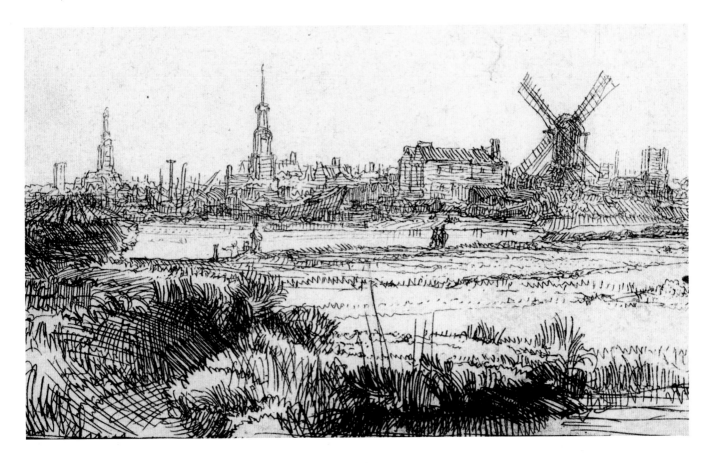

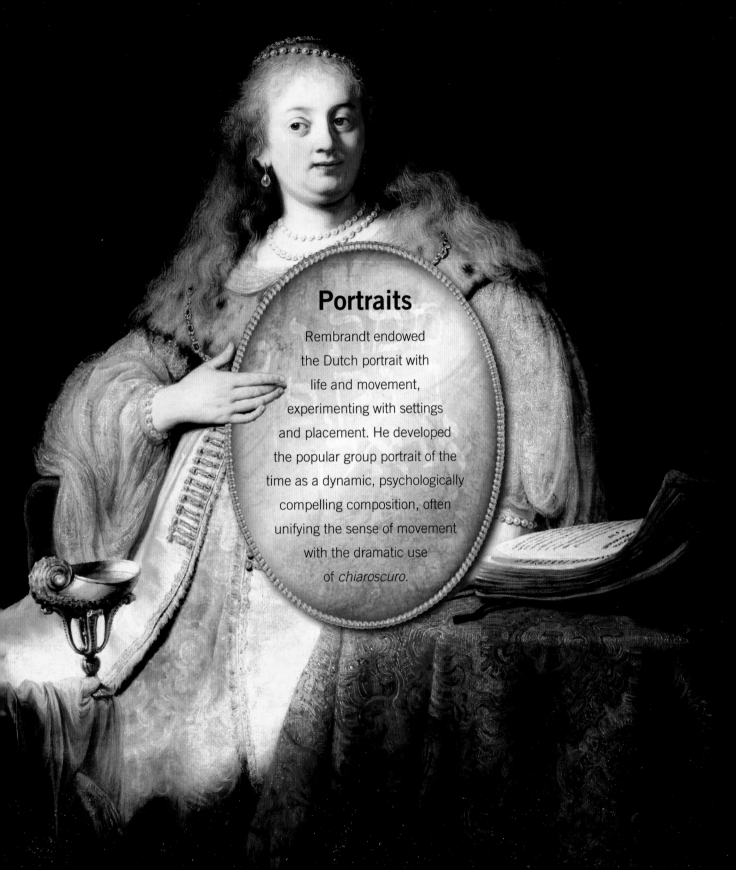

Portraits

Rembrandt endowed
the Dutch portrait with
life and movement,
experimenting with settings
and placement. He developed
the popular group portrait of the
time as a dynamic, psychologically
compelling composition, often
unifying the sense of movement
with the dramatic use
of *chiaroscuro*.

Portrait of Rembrandt's Father, 17th century
Oil on canvas • Mauritshuis, The Hague

Rembrandt's father was a miller by trade but here he is depicted as a distinguished – almost official – gentleman, wearing a gold chain with pendant. His expression is one of calm confidence.

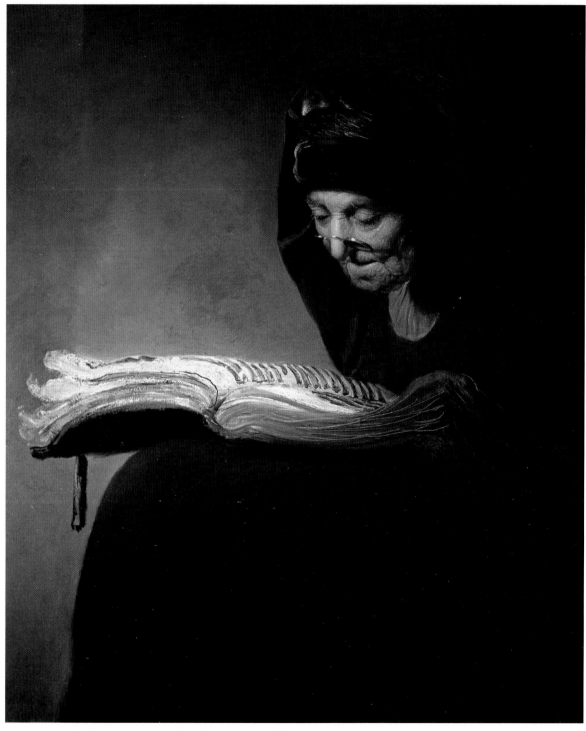

Portrait of Rembrandt's Mother, *c.* 1629
Oil on canvas, 49.8 x 40.1 cm (19²/₃ x 15⁴/₅ in)
• Wilton House, Wiltshire

The light from the large book, possibly the Bible, which his mother is reading, creates an illuminating glow. Rembrandt's mother was a devout believer known for her love of the scriptures.

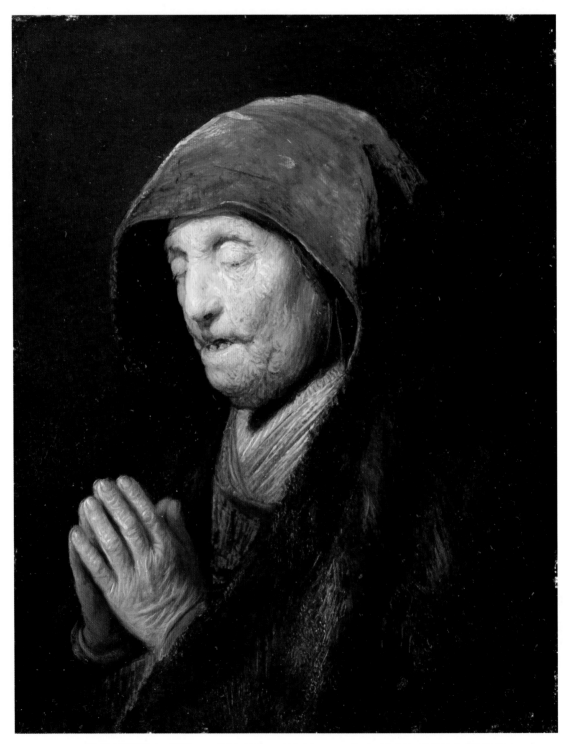

Praying Old Woman, 1630
Oil on copper, 15.5 x 12.2 cm (6 x 4⅘ in)
• Residenz-Galerie, Salzburg

This lady's face and hands are very lined, and she has lost most of her teeth.
However, her spiritual devotion in prayer bestows dignity and grace on her.

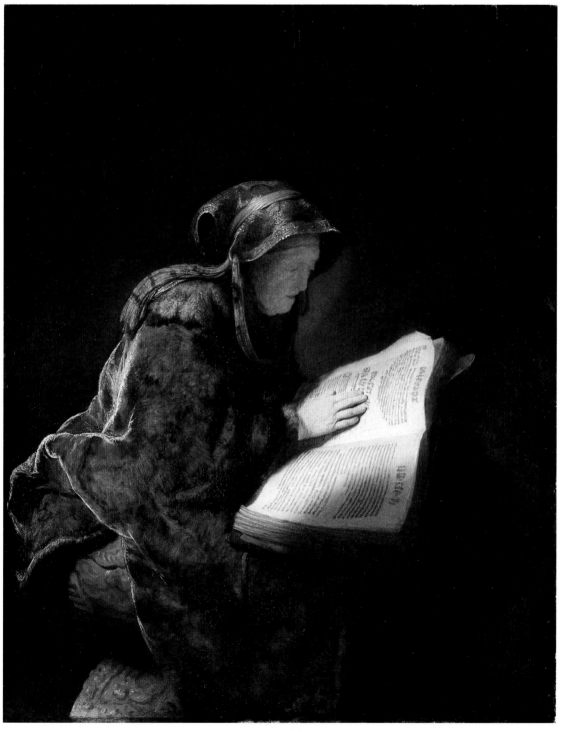

**An Old Woman Reading
(Probably the Prophetess Anna), 1631**
Oil on canvas, 60 x 48 cm (23²/₃ x 18 in)
• Rijksmuseum, Amsterdam

Anna was a widow in the New Testament who had studied the scriptures deeply and
was looking for the coming of the Saviour. The light of revelation from God's Word
illuminates the painting.

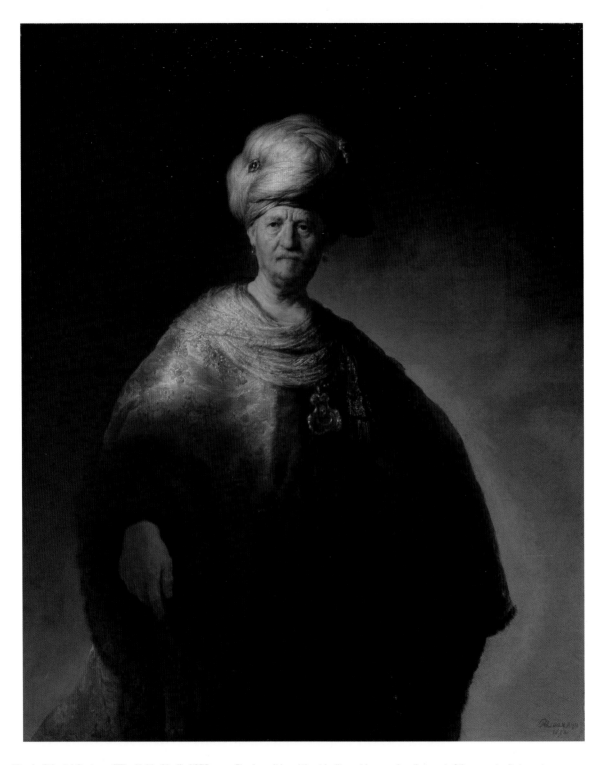

Man in Oriental Costume ('The Noble Slav'), 1632
Oil on canvas, 152.7 x 111.1 cm (60 x 43¾ in)
• Metropolitan Museum of Art, New York

Rembrandt loved theatricality and here makes the most of the opportunity to portray a distinguished oriental figure in an exotic costume with wonderful jewel-studded turban, dangling earrings and glittering pendant.

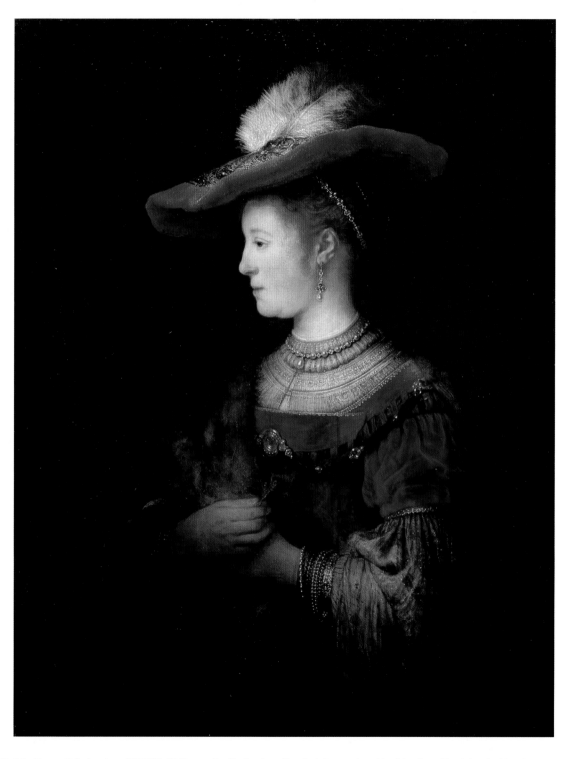

Portrait of Saskia van Uylenburgh, *c.* 1633/34–1642
Oil on panel, 99.5 x 78.8 cm (39¼ x 31 in)
• Gemäldegalerie Alte Meister, Kassel

Saskia, Rembrandt's wife, is here portrayed in all her finery. The rich reds of her dress emerge from the dark background and her elegant chapeau is topped by a white feather plume.

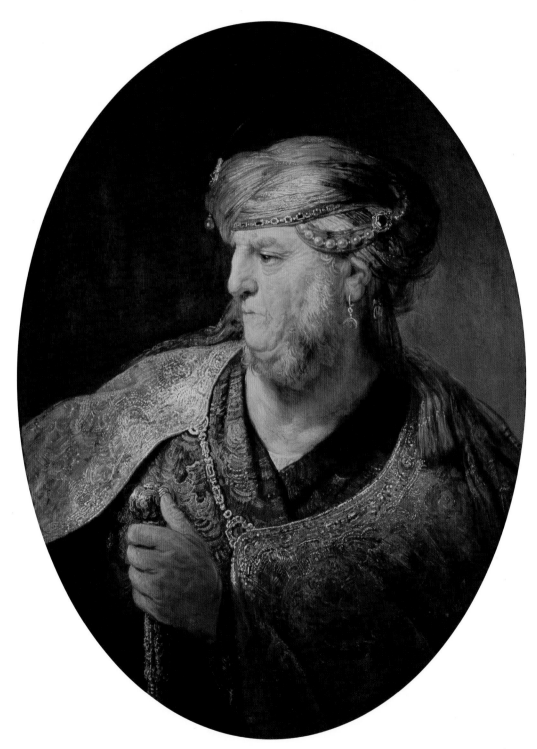

Portrait of a Man in Oriental Costume, 1633
Oil on panel, 85.8 x 63.8 cm (33⁴/₅ x 25 in)
• Alte Pinakothek, Munich

Rembrandt creates another opportunity to indulge in painting lush fabric, dazzling jewellery and shimmering tones of gold. The bearded man stares to one side in an authoritative and somewhat disconcerting manner.

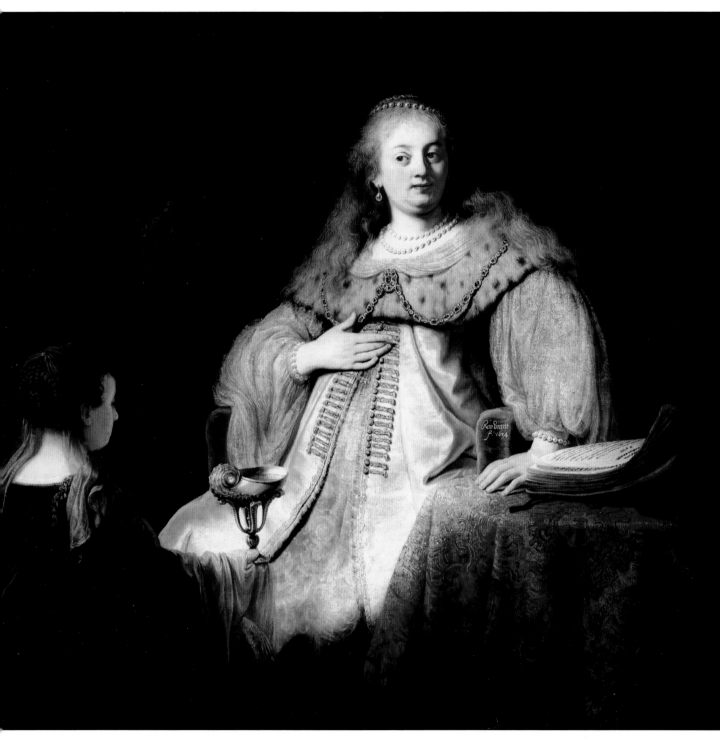

Artemisia, 1634
Oil on canvas, 142 x 152 cm (55 x 59⁴/₅ in)
• Prado, Madrid

The delicate depiction of Artemisia's feathery hair contrasts with the warm effect of the fur stole over her shoulders. The maidservant proffers a golden goblet which contains the ashes of Artemisia's husband mixed in with the drink.

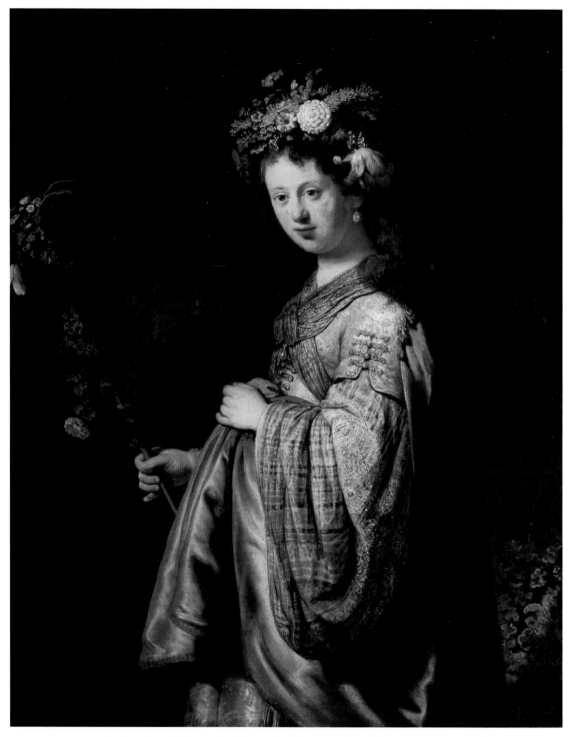

Saskia as Flora, 1634
Oil on canvas, 125 x 101 cm (49¼ x 39⅘ in)
• Hermitage, St Petersburg

Saskia is dressed as Flora, the goddess of flowers and springtime, and her pose indicates that she may be pregnant. In 1635 she gave birth to a son, but he only lived for two months.

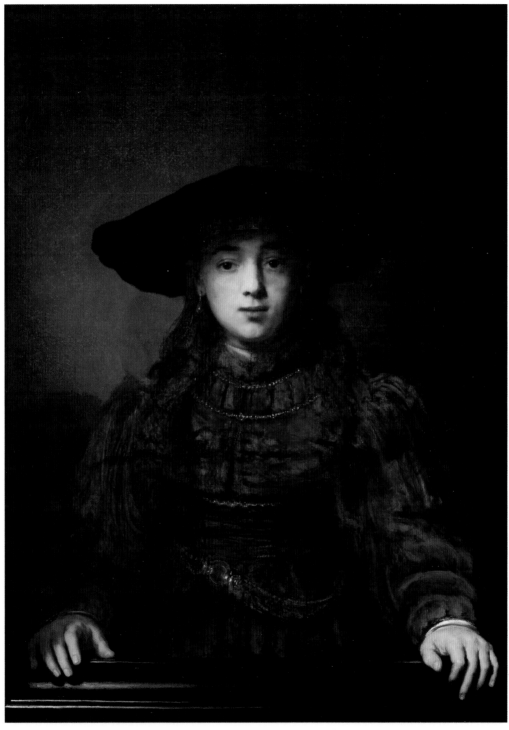

Girl in a Picture Frame, 1641
Oil on panel, 105.5 x 76.3 cm (41$\frac{1}{2}$ x 30 in)
• Royal Castle, Warsaw

Rembrandt here uses a *trompe l'oeil* effect to deceive our eyes. The hands of the elegantly coiffed girl are placed on the painted picture frame and seem to enter the viewer's space.

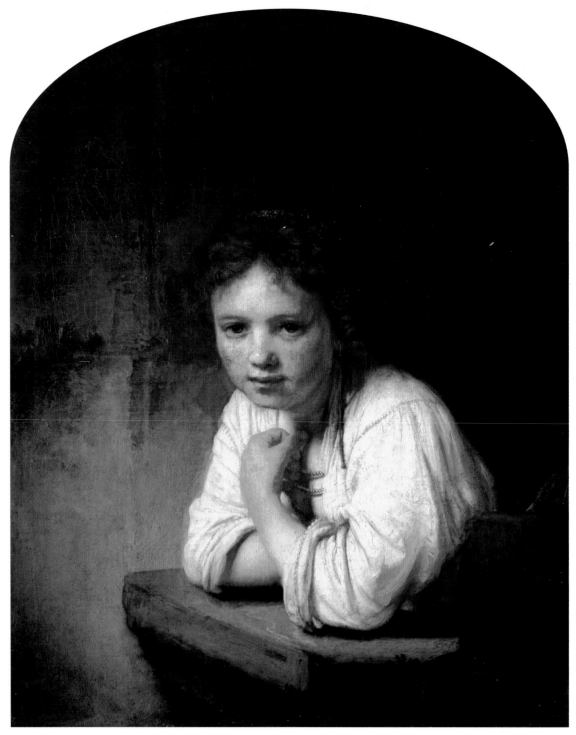

Girl at a Window, 1645
Oil on canvas, 81.6 x 66 cm (32 x 26 in)
• Dulwich Picture Gallery, London

The wide-eyed young girl with rosy cheeks conveys a sense of innocence and sweetness of character. Her white dress fills a large part of the central space and speaks of purity.

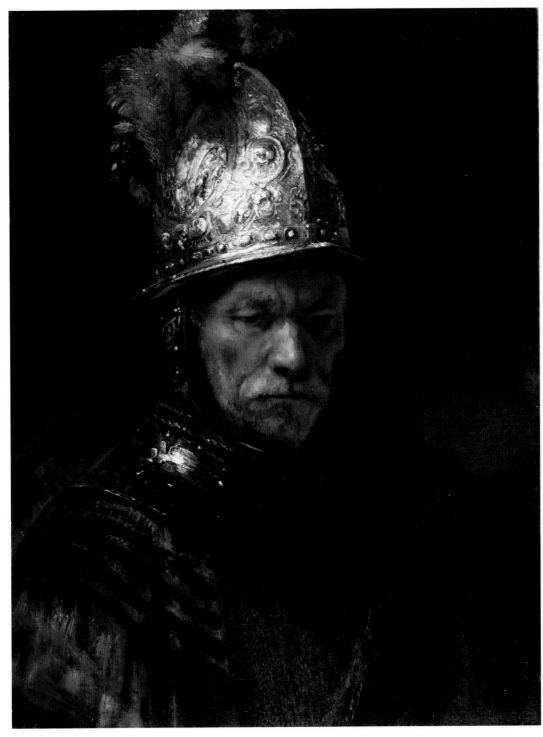

The Man with the Golden Helmet, *c.* **1650–55**
Oil on canvas, 67.5 x 50.7 cm (26²/₃ x 20 in)
• Gemäldegalerie, Berlin

This portrait of a soldier enables Rembrandt to deal with various effects of light
on different surfaces. The gold helmet glitters, while the darker collar shines with
a polished depth.

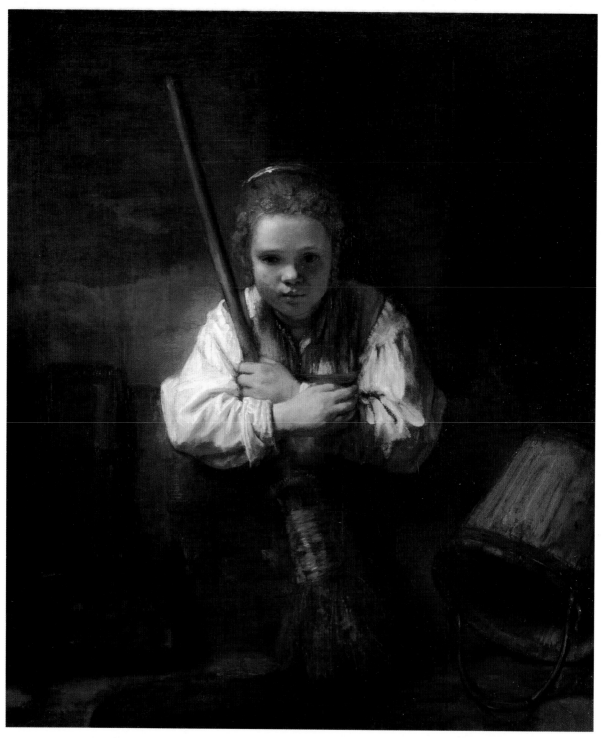

A Girl with a Broom, 1651
Oil on canvas, 107.3 x 91.4 cm (42¹/₄ x 36 in)
• National Gallery of Art, Washington D.C.

This is a study in *chiaroscuro*: the interplay of dark and light shadows to create visual effects.
One of the white sleeves of the girl's blouse glows brightly, while the other is cast in shadow.

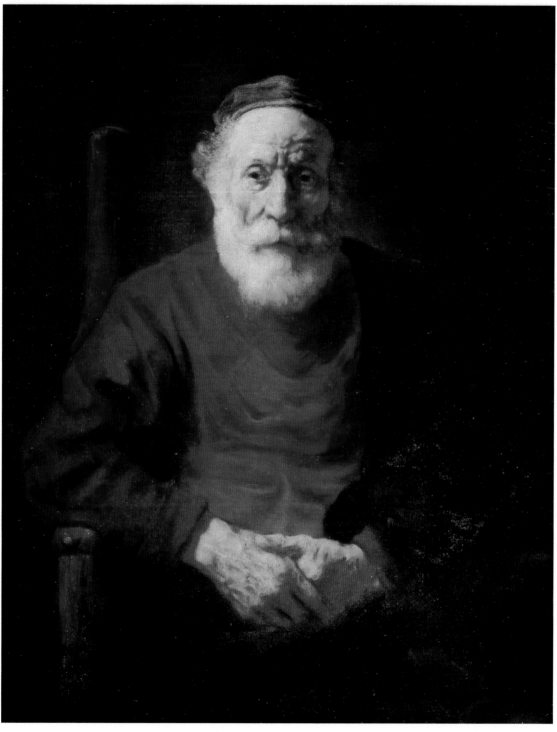

An Old Man in Red, *c.* **1652-54**
Oil on canvas, 108 x 86 cm (42¹/₂ x 34 in)
• Hermitage, St Petersburg

Rembrandt captures the dignity of old age, and combines it with the portrayal of wrinkled flesh and gnarled hands. The man's bushy white beard and deep red clothing subtly emerge from the black background.

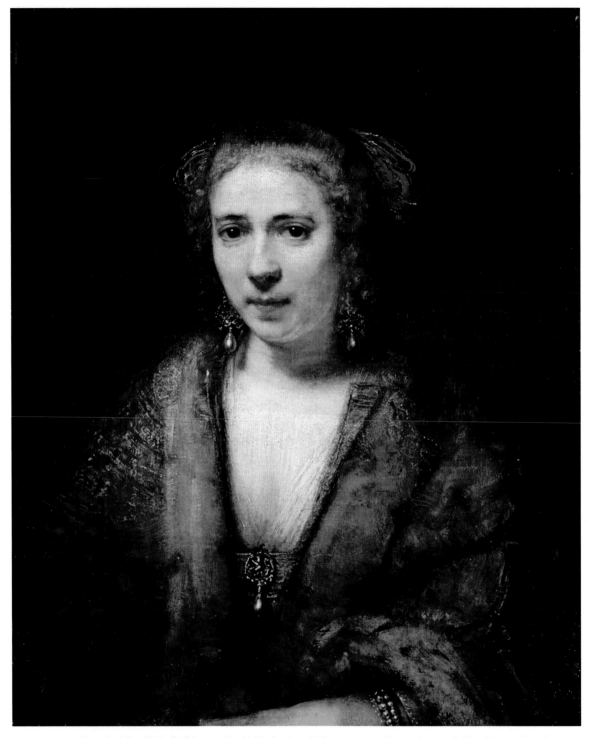

**Portrait of Hendrickje Stoffels
with a Velvet Beret, *c.* 1654**
Oil on canvas, 74 x 61 cm (29 x 24 in) • Louvre, Paris

Hendrickje, Rembrandt's former servant girl and subsequently his mistress and mother
of his daughter Cornelia, is portrayed in a quiet, thoughtful mood in this reflective work.

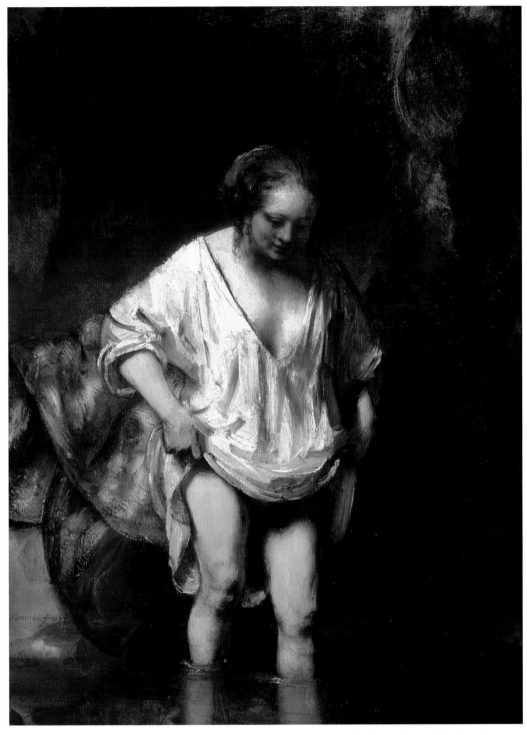

Woman Bathing in a Stream, 1654
Oil on panel, 61.8 x 47 cm (24$\frac{1}{3}$ x 18$\frac{1}{2}$ in)
• National Gallery, London

This work is thought to depict Hendrickje Stoffels as the model. Her dress of fine fabric lies on the ground behind her and she lifts her undergarment as she sensuously enjoys the water.

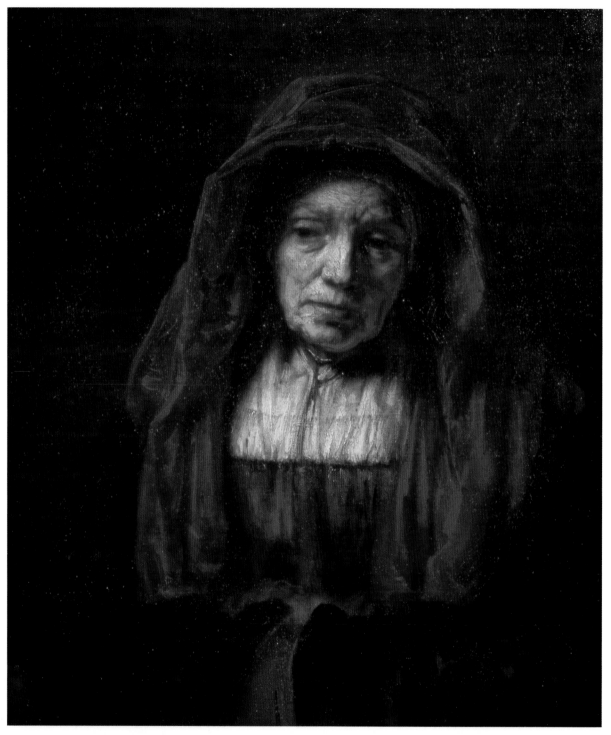

Portrait of an Old Woman, 1654
Oil on canvas, 74 x 63 cm (29 x 24⅘ in)
• Pushkin Museum, Moscow

This rather downcast lady portrayed here has been said to be Rembrandt's mother. Once again, dark red emerges from a black background highlighted by the white of the sitter's blouse.

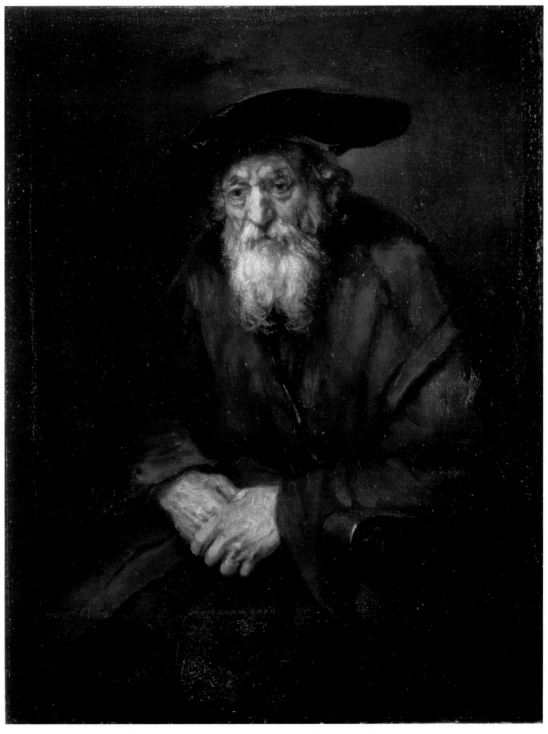

Portrait of an Old Jew, 1654
Oil on canvas, 109 x 84 cm (43 x 33 in)
• Hermitage, St Petersburg

It has been suggested that this could possibly be a companion painting to the previous painting, *Portrait of an Old Woman*. The old man's face is etched with lines and his hands are heavily veined.

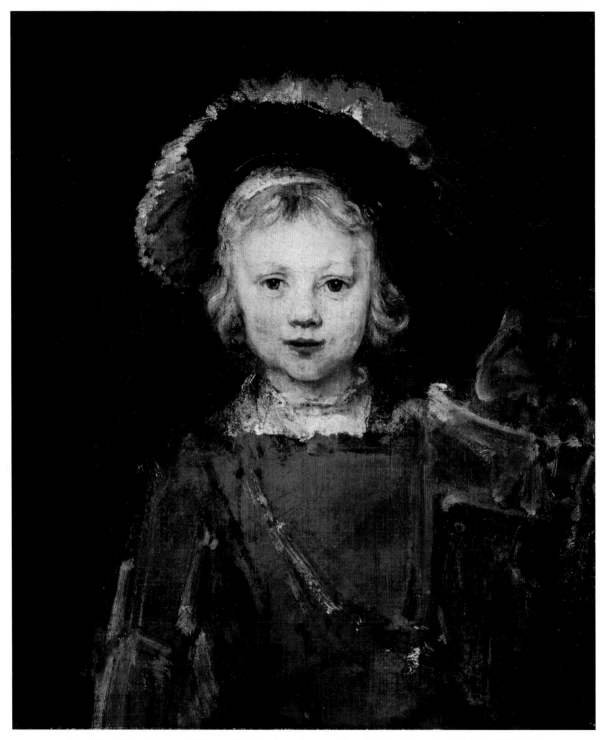

Young Boy in Fancy Dress, *c.* 1660
Oil on canvas, 64.8 x 55.9 cm (25½ x 22 in)
• Norton Simon Collection, Pasadena

This charming work representing a bright-eyed young boy is full of youthful freshness.
The depiction of the boy's clothes is roughly finished and his hat is topped with red feathers.

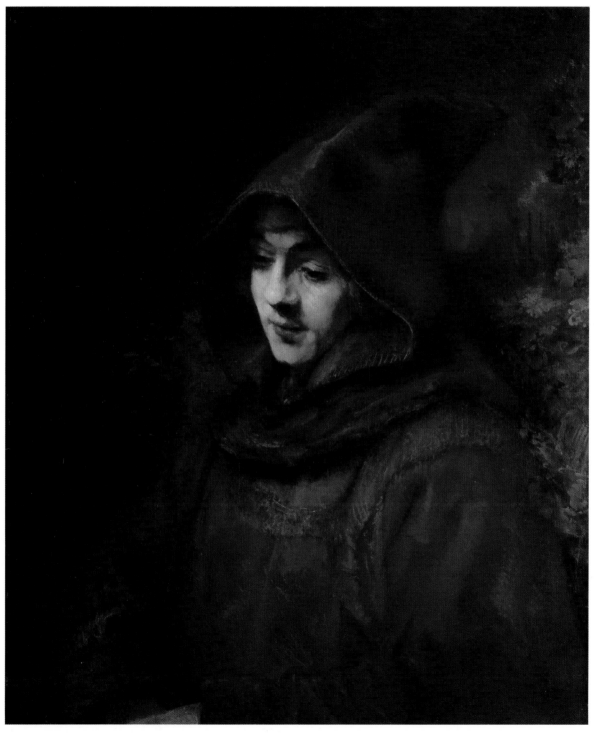

Rembrandt's Son Titus in a Monk's Habit, 1660
Oil on canvas, 79.5 x 67.7 cm (31$\frac{1}{3}$ x 26$\frac{2}{3}$ in)
• Rijksmuseum, Amsterdam

Rembrandt enjoyed dressing up his sitters in a variety of costumes.
Here he has experimented with a monk's outfit, using his son Titus as a model.

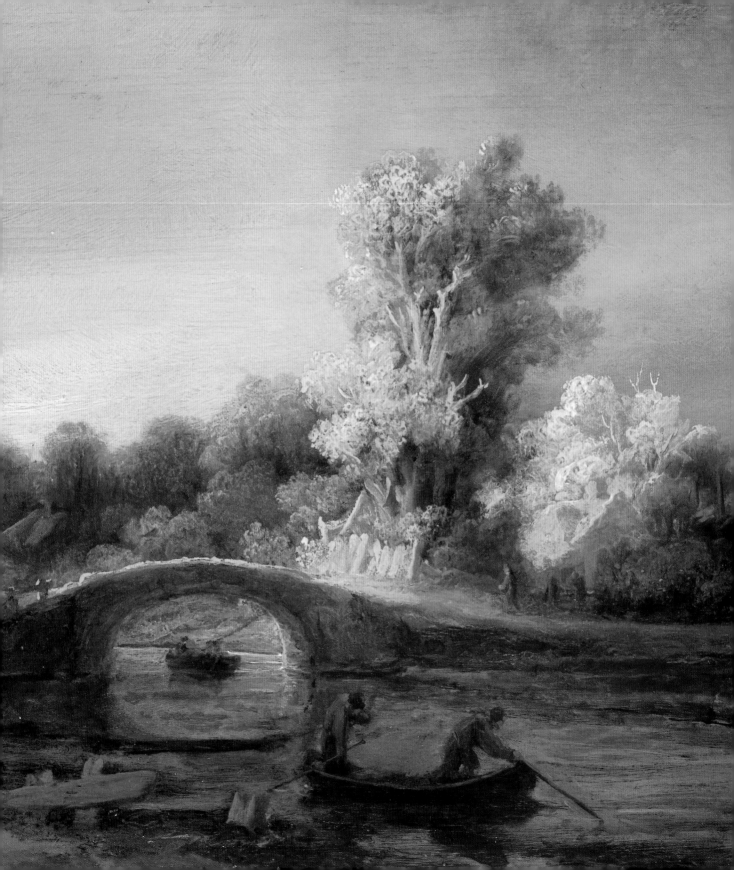

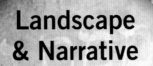

Landscape & Narrative

Rembrandt created many scenes
of the Dutch countryside and fantasy
imaginary landscapes. He is also one
of the greatest and most prolific
interpreters of biblical narrative.
His paintings of mythological subjects
are fewer in number and sometimes
obscure in content but equally
full of drama and
great beauty.

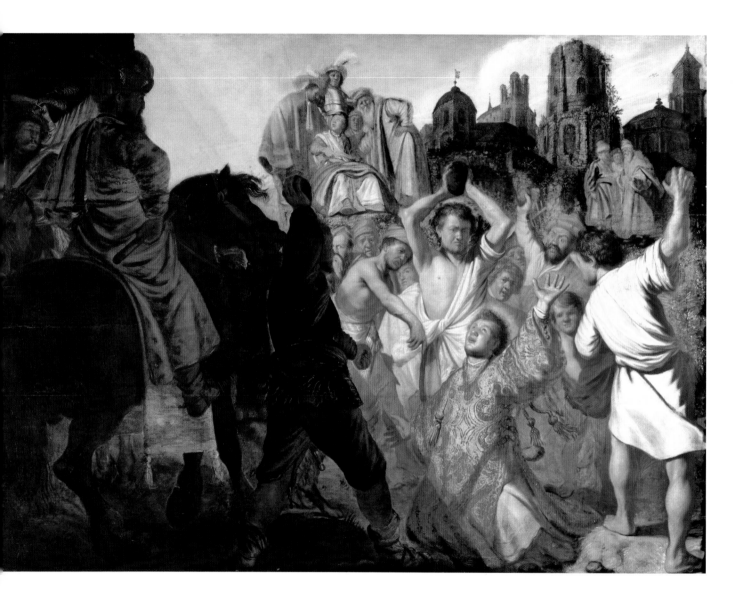

The Stoning of St Stephen, 1625
Oil on panel, 89 x 123 cm (35 x 48²/₅ in) • Musée des Beaux Arts, Lyon

This early work is the first dated painting by Rembrandt and shows the violent death of the first Christian martyr. He uses bright colour and dark shade, but his subtle use of *chiaroscuro* is still in the future.

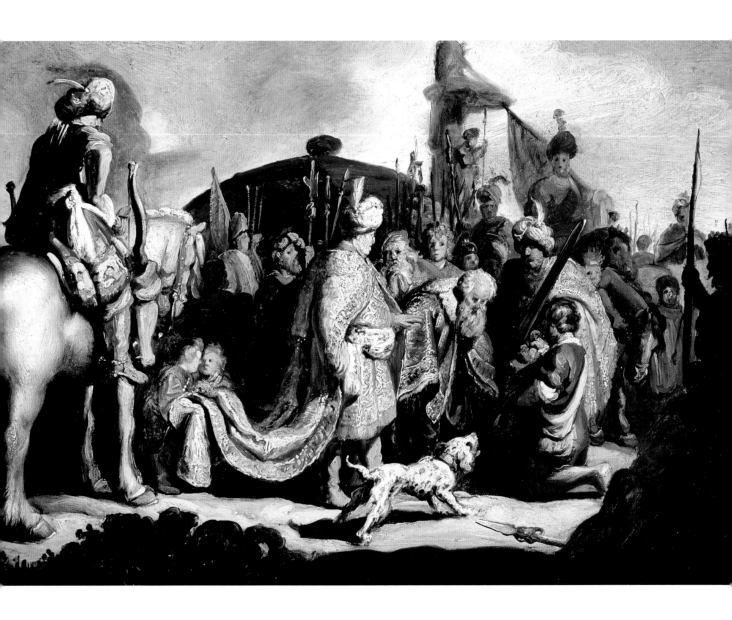

David Offering the Head of Goliath to King Saul, 1627
Oil on panel, 27.5 x 29.5 cm (10⁴/₅ x 11²/₃ in) • Kunstmuseum, Basel

In this depiction of the Old Testament story of David's victory over the giant Goliath, Rembrandt has included some humour by showing an excited dog seemingly barking at the severed head.

**Jeremiah Lamenting over the
Destruction of Jerusalem, 1630**
Oil on panel, 58 x 46 cm (22⁴/₅ x 18 in) • Rijksmuseum, Amsterdam

Jeremiah sits dejected, alone and inconsolable, as Jerusalem is destroyed. He appears to have taken refuge in a cave in which some rich and precious things have been placed as reminders of Jerusalem's prosperous past.

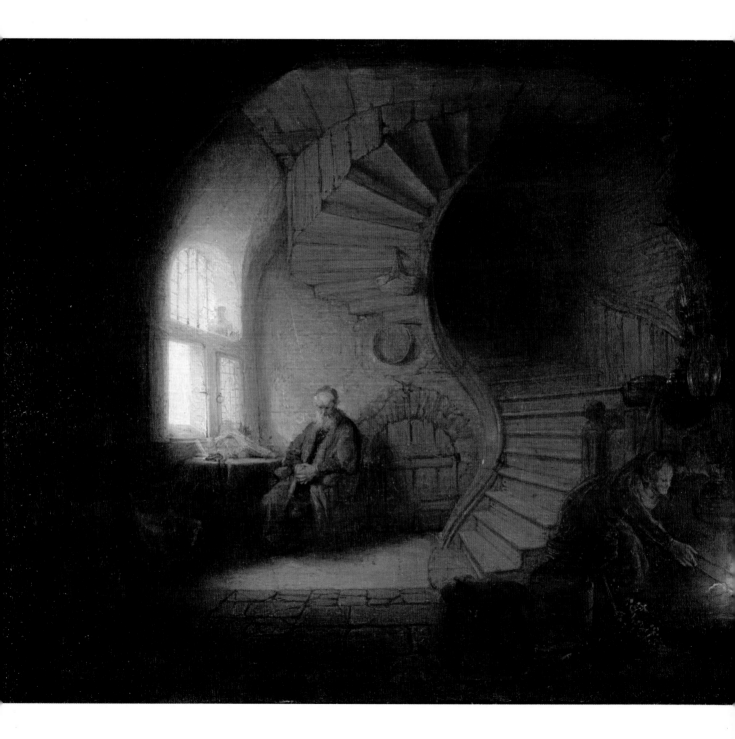

Philosopher in Meditation, 1632
Oil on panel, 28 x 34 cm (11 x 13²/₅ in) • Louvre, Paris

A lone figure, deep in thought, sits close to a window through which pours a golden and radiant light. A staircase winds upwards into obscurity and in the gloom an old woman looks after the fire.

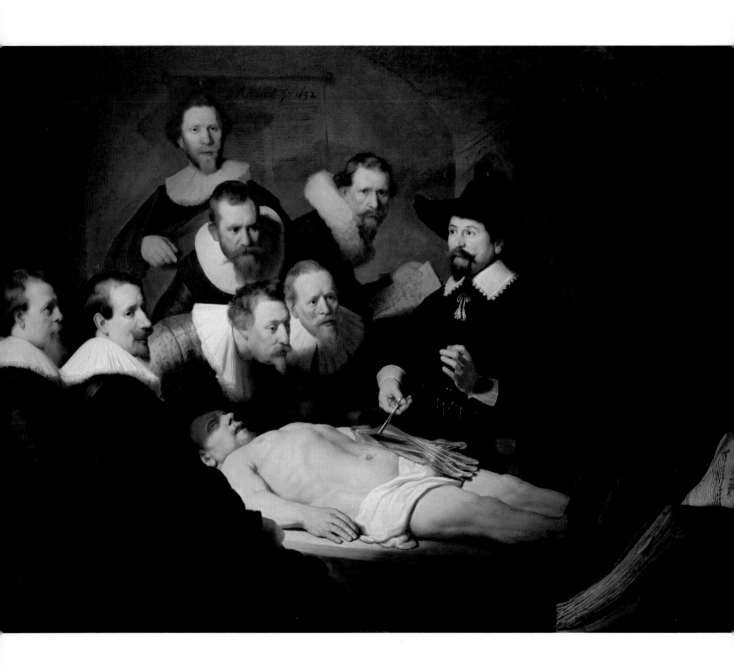

The Anatomy Lesson of Dr Nicolaes Tulp, 1632
Oil on canvas, 169.5 x 216 cm (66³/₄ x 85 in)
• Mauritshuis, The Hague

The prominent Amsterdam surgeon Dr Nicolaes Tulp explains the anatomy of the arm and hand by a demonstration dissection. The group of men observing are all individual portraits painted by Rembrandt.

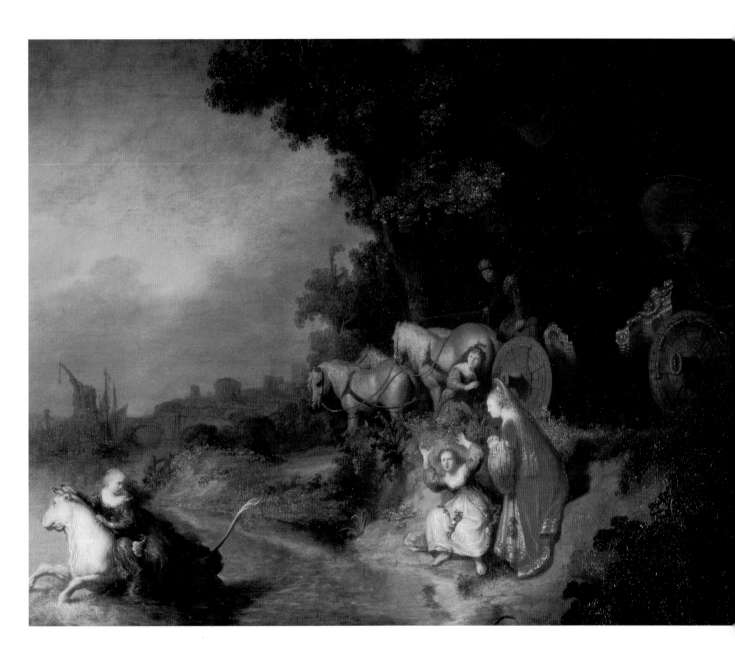

The Abduction of Europa, 1632
Oil on wood, 60 x 77.5 cm (23²/₃ x 30¹/₂ in)
• J. Paul Getty Museum, Los Angeles

The Greek myth describes how Europa is carried away by the Greek God Zeus disguised as a white bull. Glowing light highlights Europa, the bull and the group of shocked attendants.

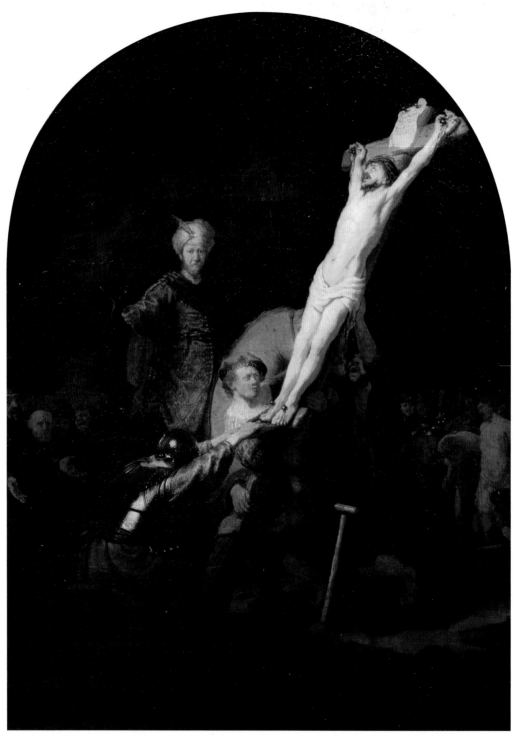

The Raising of the Cross, *c.* 1633
Oil on canvas, 96.2 x 72.2 cm (38 x 28⅖ in)
• Alte Pinakothek, Munich

To the left of the cross, a richly dressed man, who looks rather like Rembrandt himself, boldly confronts the viewer in a challenging and almost defiant manner.

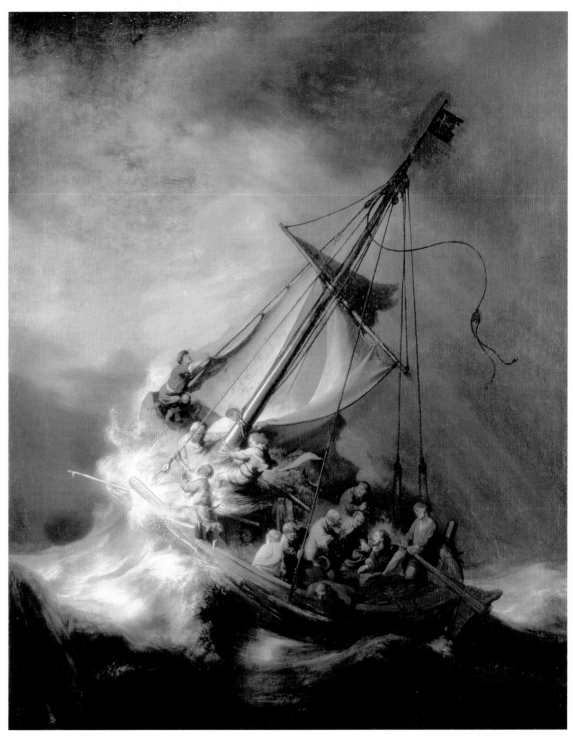

The Storm on the Sea of Galilee, *or* Christ in the Storm, 1633
Oil on canvas, 160 x 128 cm (63 x 50⅖ in)
• Isabella Stewart Gardner Museum, Boston

This is the only known seascape by Rembrandt. Here he captures the ferocity of the storm, the dramatic angle of the boat buffeted by the waves and the reactions of the men to their plight.

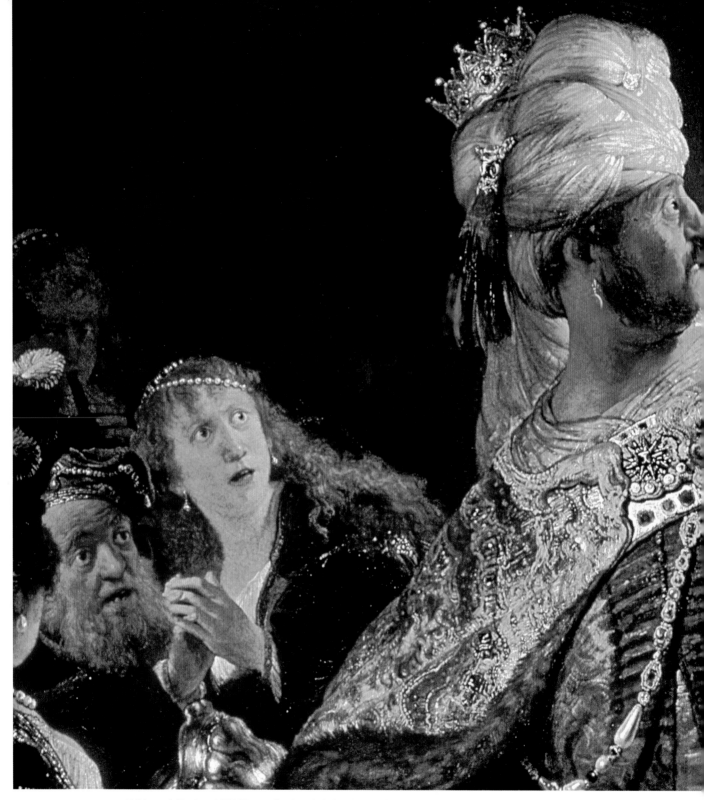

Belshazzar's Feast, *c.* **1636-38**
Oil on canvas, 167.6 x 209.2 cm (66 x 82²/₅ in)
• National Gallery, London

Rembrandt depicts the story from the Old Testament according to which Belshazzar is paralysed with fear when the hand of God writes a message on the wall to tell him that his kingdom is finished.

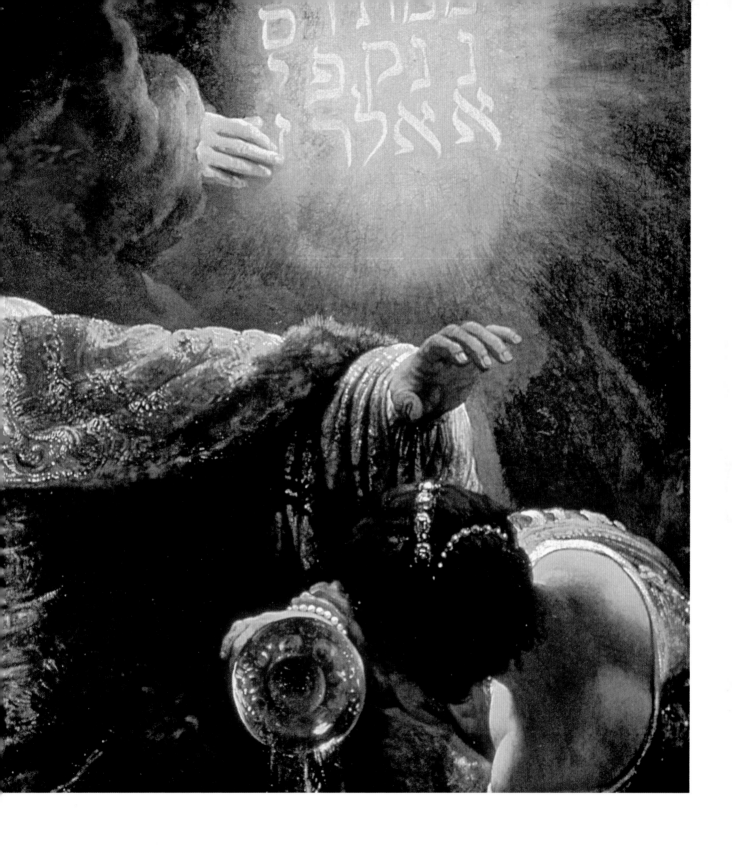

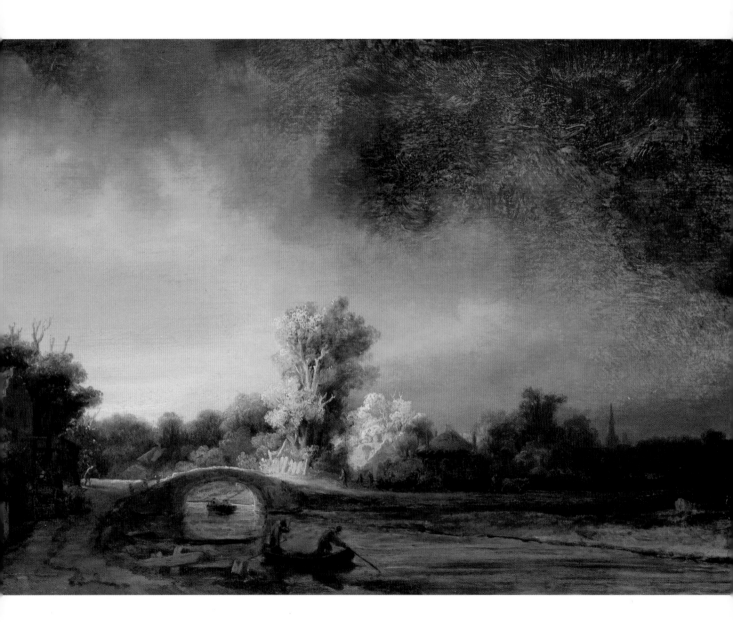

Landscape with a Stone Bridge, 1638
Oil on panel, 29.5 x 42.5 cm (11²/₃ x 16³/₄ in)
• Rijksmuseum, Amsterdam

The flash of strong light upon the trees is threatened by the heavy, dark clouds which roll across the sky predicting a deluge over this bucolic Dutch landscape.

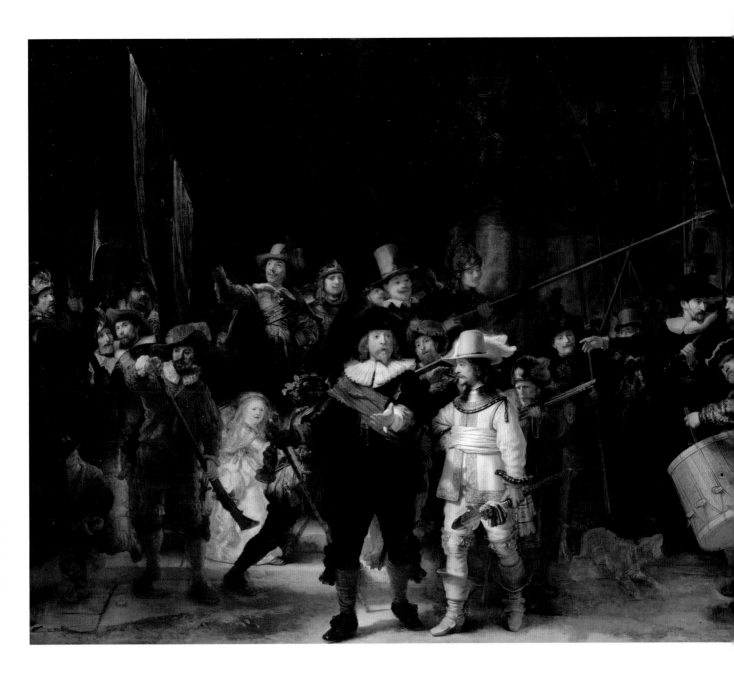

The 'Night Watch' (Militia Company of District II under the Command of Captain Frans Banninck Cocq), 1642
Oil on canvas, 363 x 438 cm (143 x 172²/₅ in)
• Rijksmuseum, Amsterdam

The gathered members of the militia company of Captain Frans Banninck Cocq prepare their weapons at his command in this animated group portrait painted at the height of Rembrandt's career.

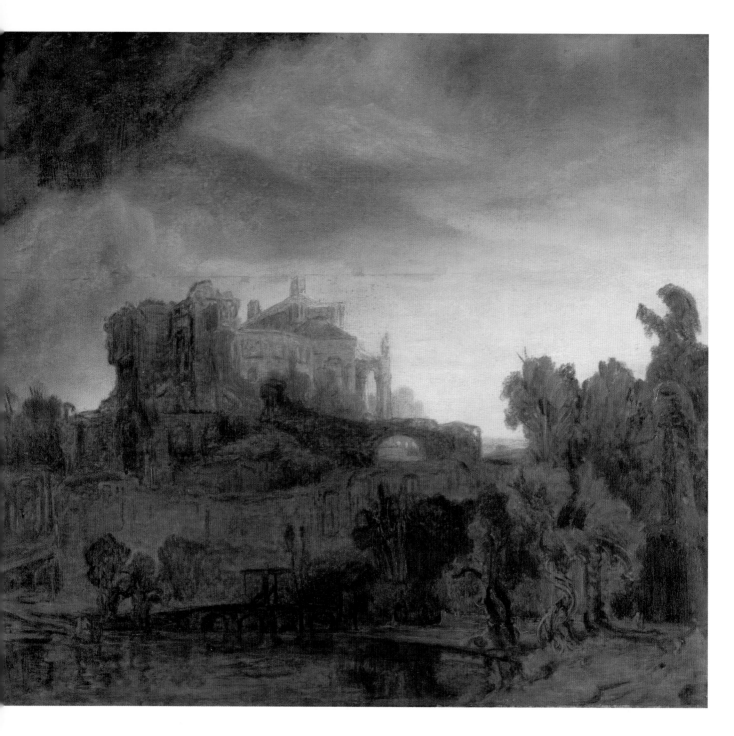

Landscape with a Castle, *c.* 1643
Oil on wood, 44.5 x 70 cm (17¹/₂ x 27²/₃ in) • Louvre, Paris

The landscape is painted in bold and strong shades of brown, whereas the castle, situated on higher ground, is almost like a mirage, shimmering in shades of grey and white.

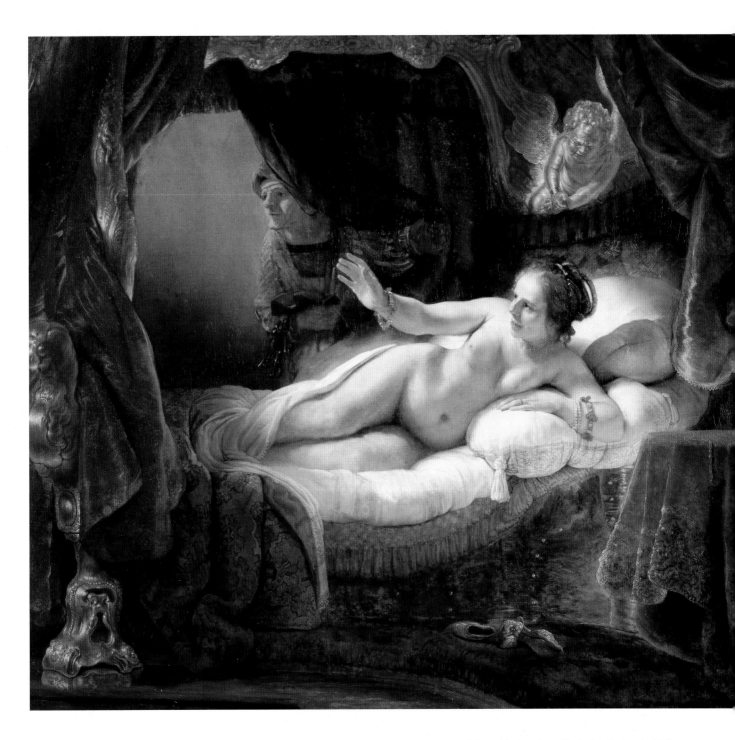

Danaë, 1643
Oil on canvas, 185 x 203 cm (72⅘ x 80 in)
• Hermitage, St Petersburg

This sumptuous painting of Danaë, mistress of the god Jupiter, glows with shades of red and gold. It was badly damaged in an attack when acid was thrown over it but has been restored.

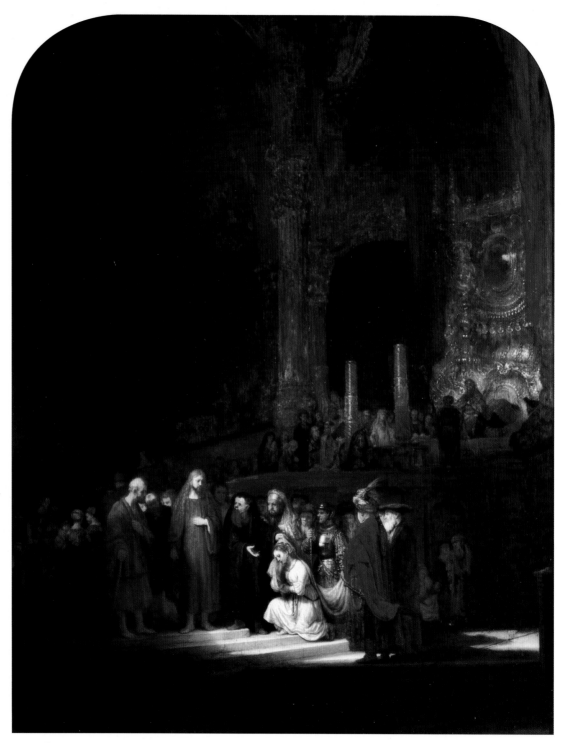

The Woman Taken in Adultery, 1644
Oil on wood, 83.8 x 65.4 cm (33 x 25¾ in)
• National Gallery, London

The sinful woman, her white dress glowing with light, is placed in the centre of the work.
Jesus, his face full of compassion, uses the incident to teach that God forgives sinners.

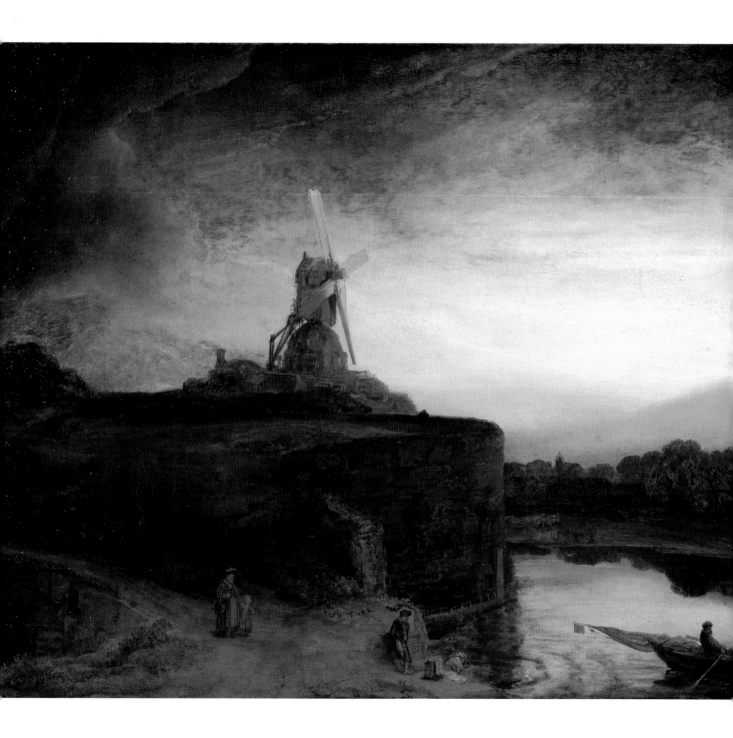

The Mill, 1645–48
Oil on canvas, 87.6 x 105.6 cm (34$\frac{1}{2}$ x 41$\frac{2}{3}$ in)
• National Gallery of Art, Washington D.C.

This view of a mill perched high on elevated ground is full of atmospheric foreboding. The dark clouds threaten the expanse of blue sky and the quiet pleasures of the boatman and walkers.

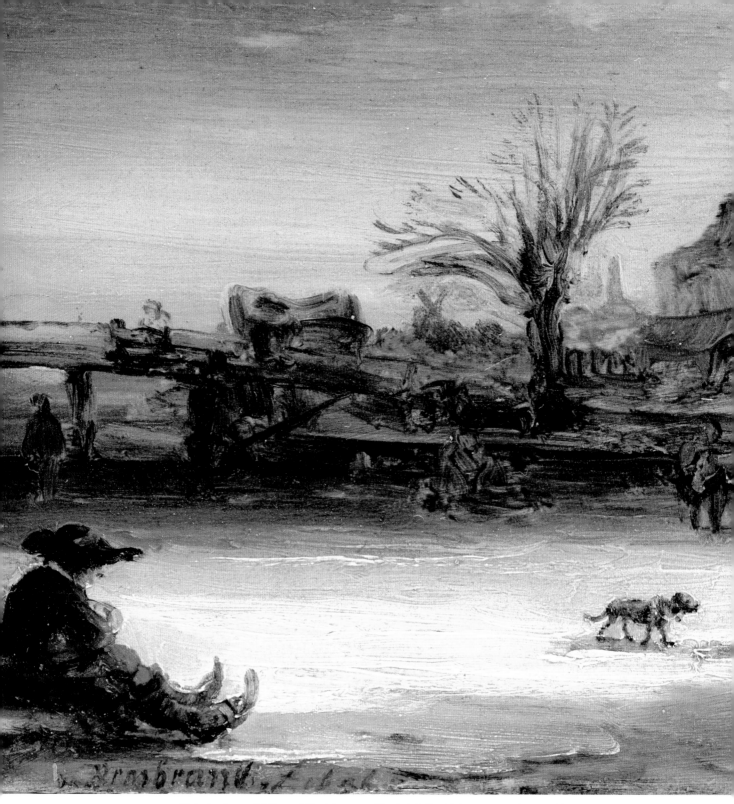

Winter Landscape, 1646
Oil on panel, 16.6 x 23.4 cm (6½ x 9¼ in)
• Gemäldegalerie Alte Meister, Kassel

This winter scene of Dutch daily life, with bare trees, steely sky and frozen river, charmingly depicts peasants and ice-skaters, together with a dog and other animals.

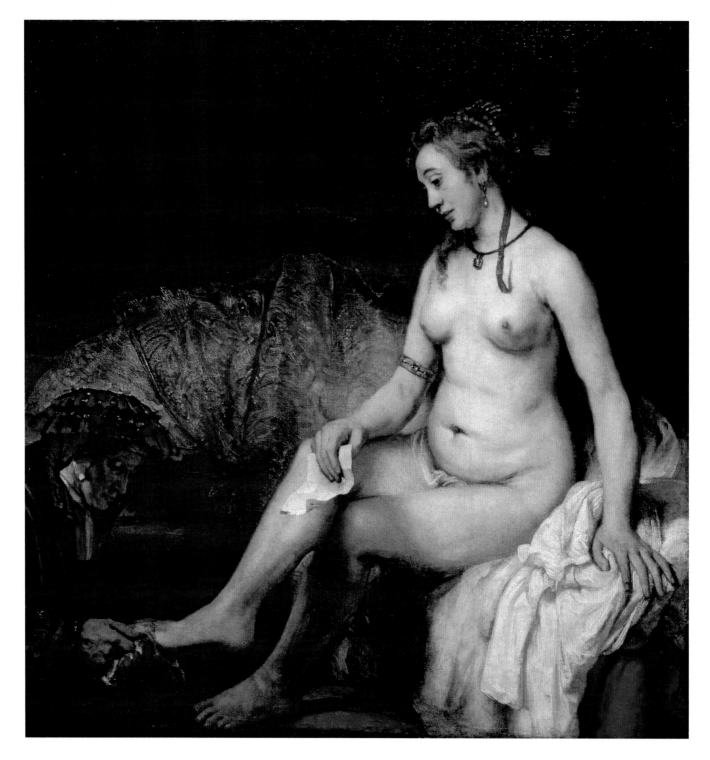

Bathsheba Bathing, 1654
Oil on canvas, 142 x 142 cm (56 x 56 in) • Louvre, Paris

Hendrickje, Rembrandt's mistress, poses as Bathsheba in this story from the Old Testament.
She is lost in thought, clutching what is probably a letter from King David in her hand.

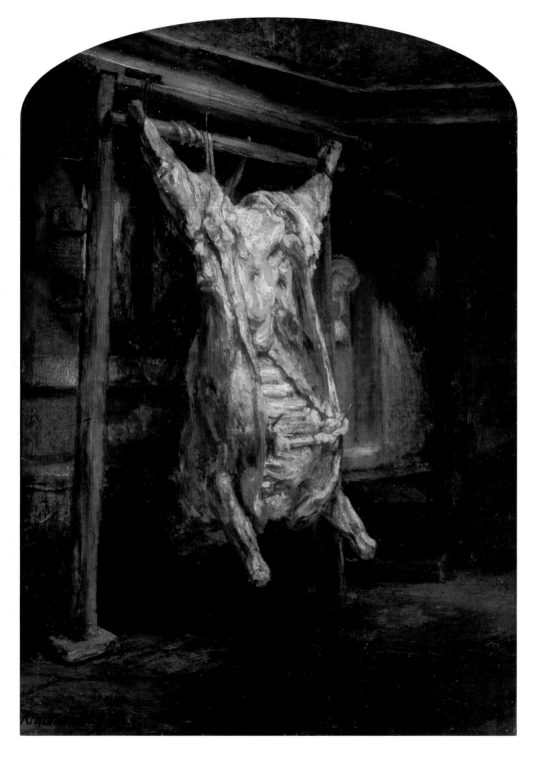

The Slaughtered Ox, 1655
Oil on wood, 94 x 67 cm (37 x 26²/₅ in) • Louvre, Paris

This painting is almost a still life except for the servant girl in the shadows to the right of the ox. Rembrandt uses thick wedges of paint in shades of red and white to depict the flesh and blood.

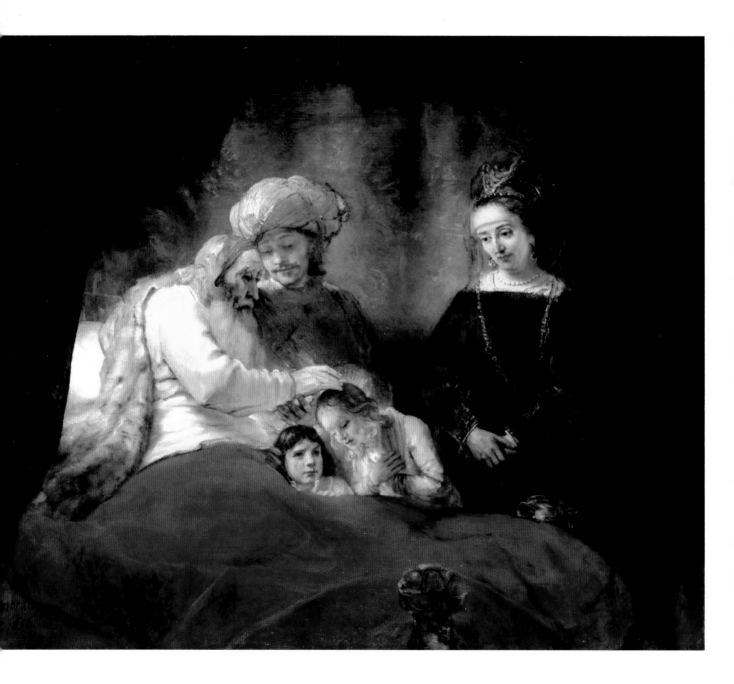

Jacob Blessing the Sons of Joseph, 1656
Oil on canvas, 173 x 209 cm (68 x 82⅓ in)
• Gemäldegalerie Alte Meister, Kassel

Jacob passes the family blessing for the oldest son to the younger son instead.
Joseph tries to intervene and guide his father's hand but Jacob has not made a mistake.

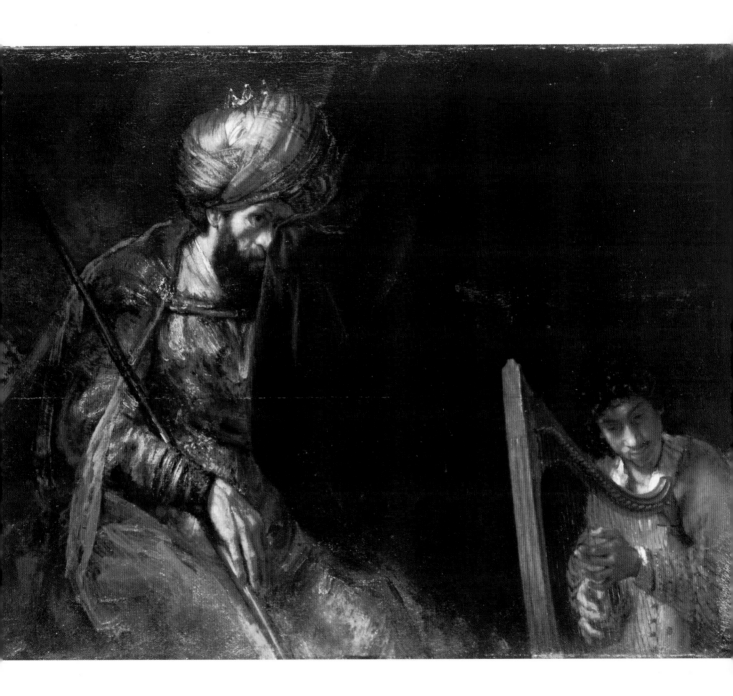

David Playing the Harp Before Saul, *c.* **1658–59**
Oil on canvas, 130.5 x 164 cm (51²/₅ x 64²/₃ in)
• Mauritshuis, The Hague

Saul is represented in all the finery of kingship, while David the simply clad shepherd boy
plays his harp to calm the agitation that Saul feels after being told he will lose the kingship.

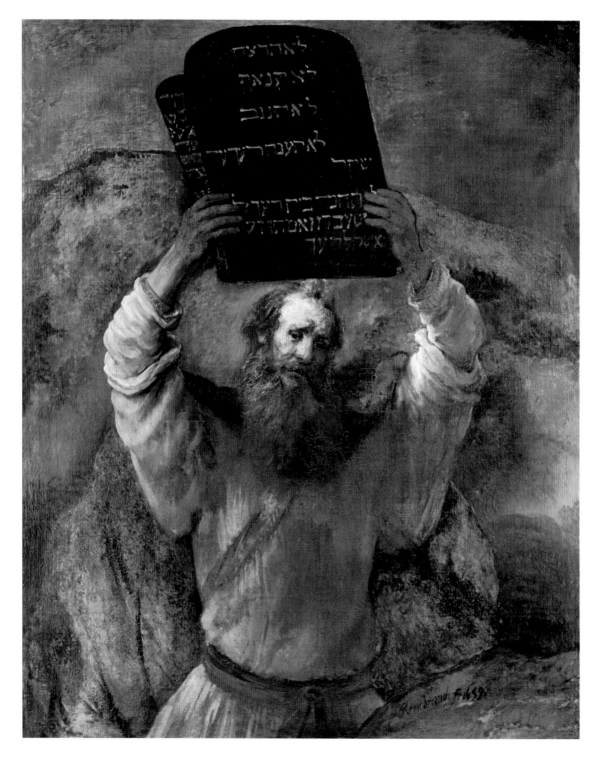

Moses Smashing the Tablets of the Law, 1659
Oil on canvas, 168.5 x 136.5 cm (66¹/₃ x 53³/₄ in)
• Gemäldegalerie, Berlin

The rough texture of the brush strokes evokes the fury that Moses feels at the sinful behaviour of God's people. His eyes, however, convey pain and sadness as he holds above his head the tablet inscribed with God's law.

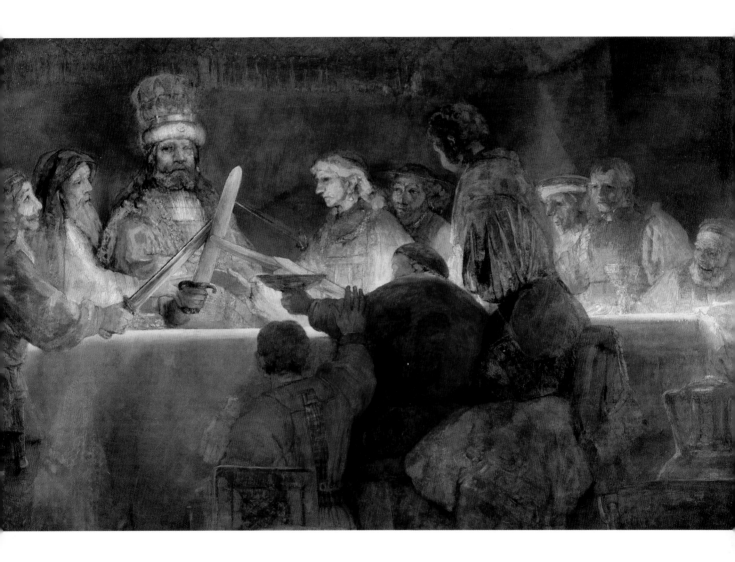

The Conspiracy of the Batavians under Claudius Civilis, 1661–62
Oil on canvas, 196 x 309 cm (77¼ x 121⅔ in)
• Nationalmuseum, Stockholm

The table glows with burning light, as if to reflect the ardour of the group of volunteers from the Batavi tribe who pledge their oath to fight with Claudius Civilis to throw off Roman rule.

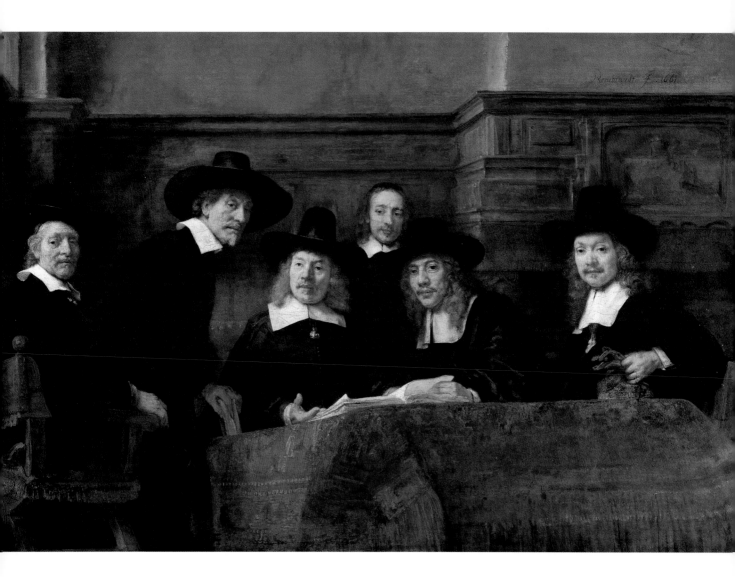

The Sampling Officials of the Amsterdam Drapers' Guild, 1662
Oil on canvas, 191.5 x 279 cm (75²/₅ x 109⁴/₅ in)
• Rijksmuseum, Amsterdam

The corner of the table covered with a rich red cloth projects out towards the viewer, drawing us into the picture space. One of the men rises to his feet to greet us as if we have just entered the room.

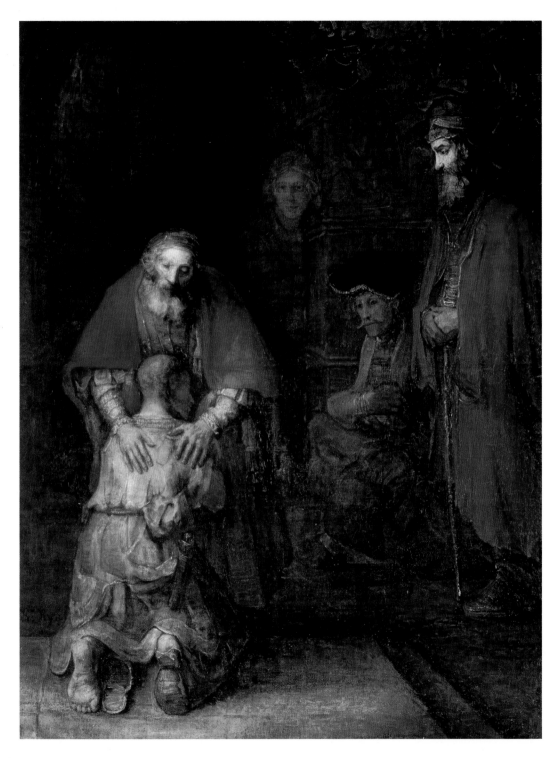

The Return of the Prodigal Son, *c.* 1668–69
Oil on canvas, 262 x 205 cm (103 x 80¾ in)
• Hermitage, St Petersburg

The father shows forgiveness, tenderness and compassion, as with large, protective hands he embraces his wayward son. The latter, wearing worn sandals and tattered clothes, turns his head to one side, accepting his father's unconditional love.

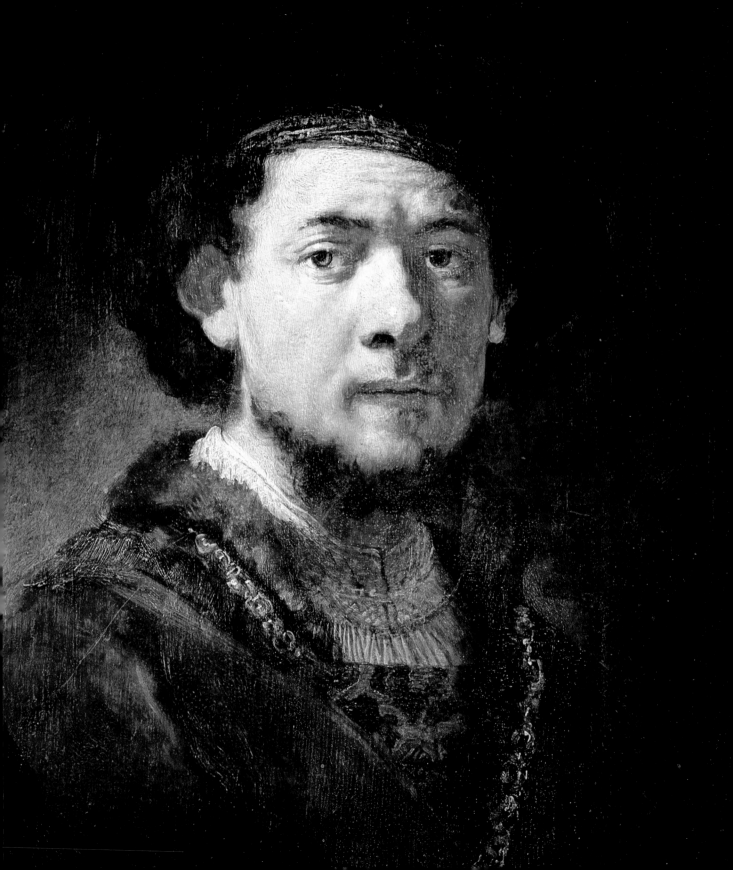

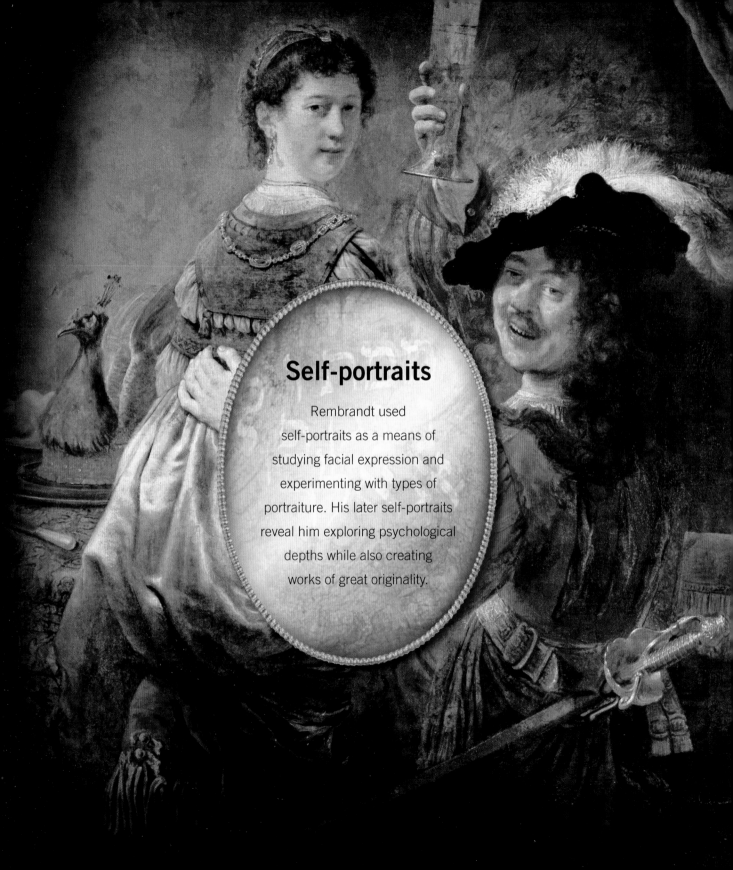

Self-portraits

Rembrandt used self-portraits as a means of studying facial expression and experimenting with types of portraiture. His later self-portraits reveal him exploring psychological depths while also creating works of great originality.

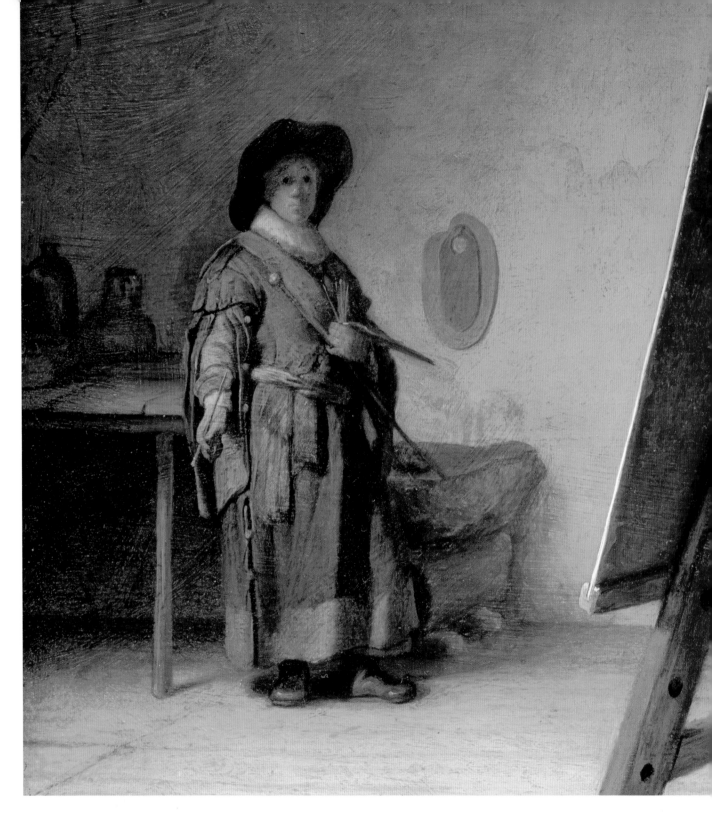

Artist in His Studio, *c.* 1627–28
Oil on panel, 24.8 x 31.7 cm (9⁴/₅ x 12¹/₂ in)
• Museum of Fine Arts, Boston

The perspective lines of the worn floorboards, the crack in the plaster, the shadow created by the easel and the mottled shading on the wall all tell us that Rembrandt is already a master of his art.

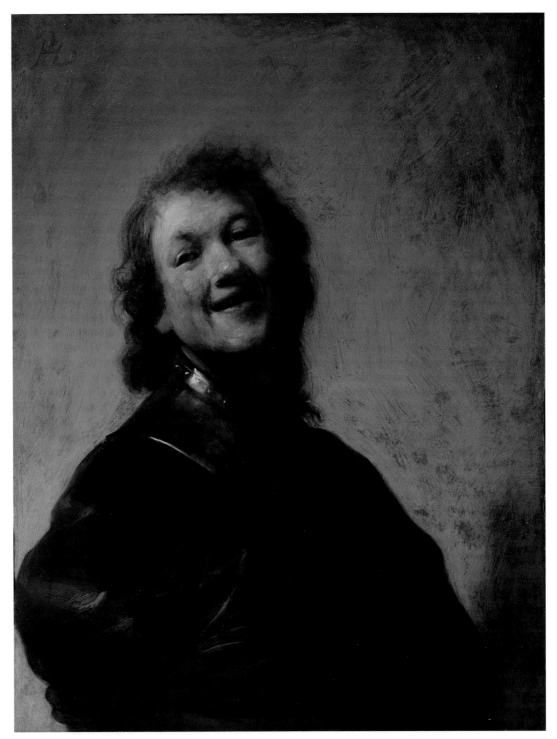

Rembrandt Laughing, *c.* 1628
Oil on copper, 22.2 x 17.1 cm (8¾ x 6¾ in)
• J. Paul Getty Museum, Los Angeles

This is an example of a 'tronie': a head and shoulders or half-length portrait featuring different facial expressions and moods. Tronies often depicted anonymous people but were sometimes self-portraits.

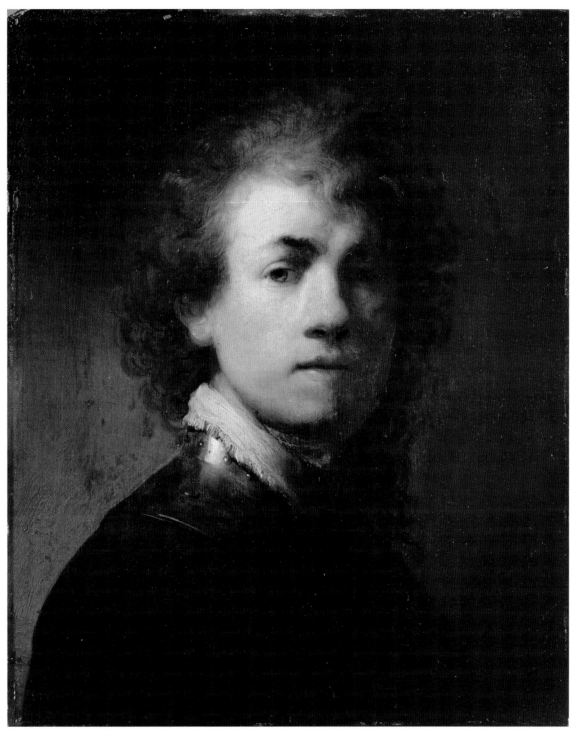

Self-portrait as a Courtly Squire, c. 1629
Oil on panel, 38 x 31 cm (15 x 12¼ in)
• Germanisches Nationalmuseum, Nuremberg

Here Rembrandt looks better presented than is often the case. It is thought that Constantijn Huygens may have encouraged Rembrandt to smarten up as a prelude to working for the Prince of Orange.

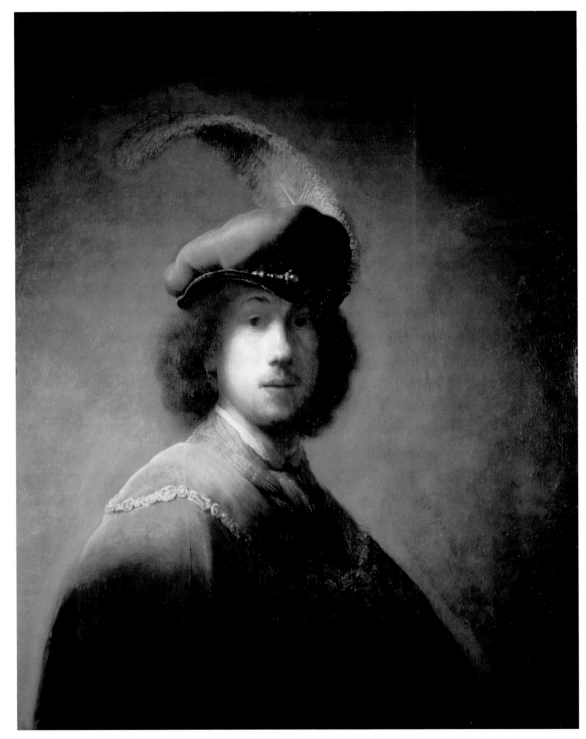

Self-portrait, 1629
Oil on panel, 89.7 x 73.5 cm (35$^{1}/_{3}$ x 29 in)
• Isabella Stewart Gardner Museum, Boston

This is another example of Rembrandt looking more distinguished. His hat is decorated with a dashing plume, round his neck he wears a scarf of golden thread and round his shoulders he wears a gold chain.

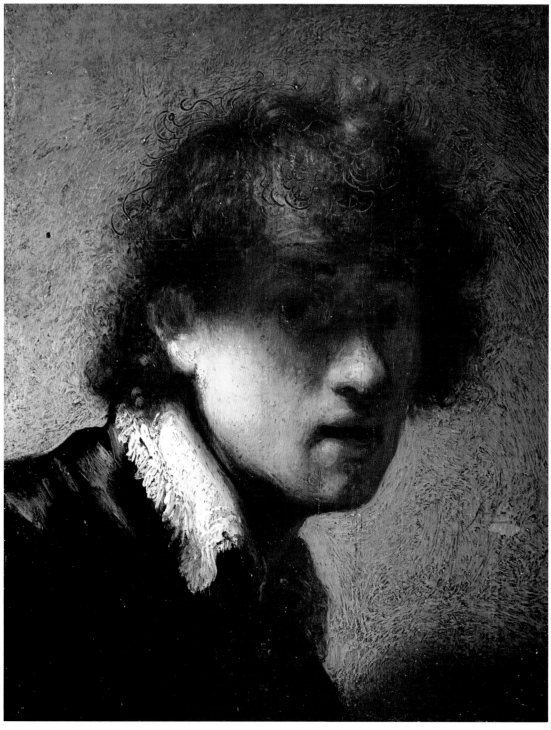

Head of a Young Man, or Self-portrait, 1629
Oil on panel, 15.5 x 12.7 cm (6 x 5 in)
• Alte Pinakothek, Munich

With his look of surprise and tousled hair, the man in this portrait evokes the freshness and casualness of youth. The white collar with frilled edging is elegant but somewhat crumpled.

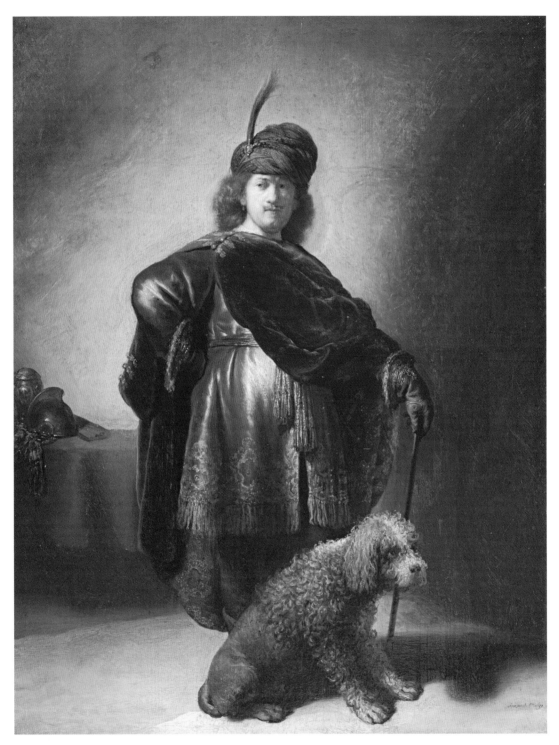

Self-portrait in Oriental Costume, 1631
Oil on panel, 66 x 52 cm (26 x 20½ in)
• Petit Palais, Musée des Beaux-Arts de la ville de Paris, France

Rembrandt has dressed up as an oriental ruler in a silk robe and velvet cloak complete with exotic turban. With one hand he leans on a walking stick, while the other hand is on his hip in a striking 'swagger' pose.

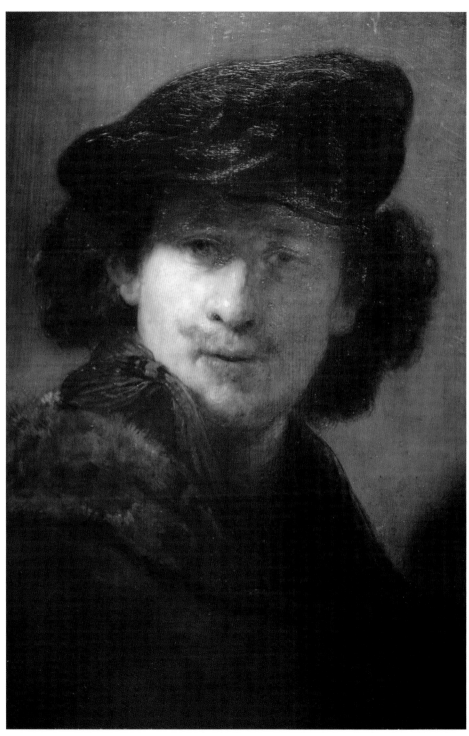

Self-portrait with Velvet Beret and Furred Mantel, 1634
Oil on oak, 58 x 48 cm (22⁴/₅ x 19 in)
• Gemäldegalerie, Berlin

With velvet hat, fur jacket and a moustache, Rembrandt is shown in this portrait as a dashing young beau: serious, self-contained and confident, successfully beginning to find his place in the world.

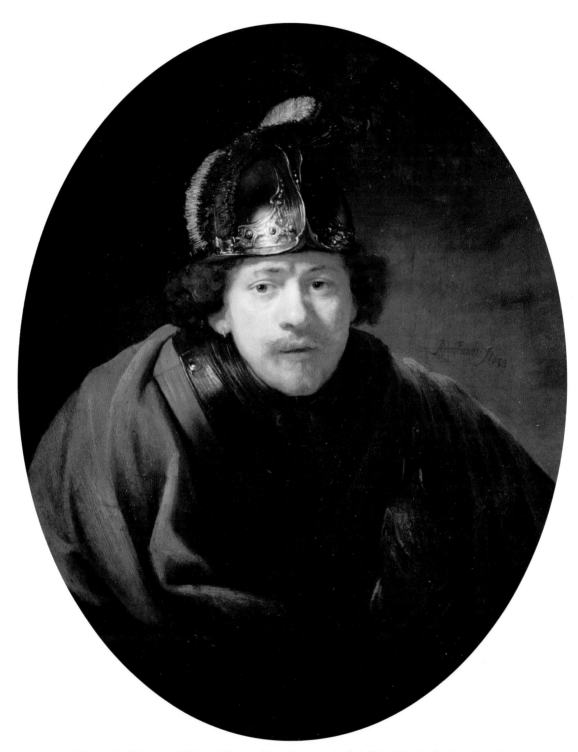

Self-portrait with Helmet, 1634
Oil on panel, 80.5 x 66 cm (31³/₄ x 26 in)
• Gemäldegalerie Alte Meister, Kassel

This portrait is another example of a half-length 'tronie'. Rembrandt has dressed himself in a cloak and a piece of armour which protects the throat, called a gorget, and he is wearing a helmet topped with two feathers.

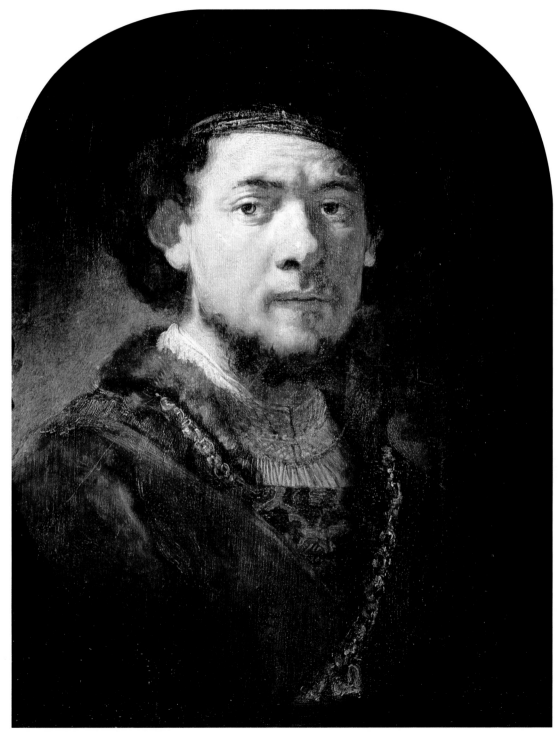

Portrait of a Man with a Gold Chain, or Self-portrait, 1634–36
Oil on panel, 57.5 x 44 cm (22²/₃ x 17¹/₃ in)
• Museu de Arte, São Paulo

This painting has been considered to be a portrait, a self-portrait or even a work by another artist. The man is dressed well and appears prosperous, although his expression is enigmatic.

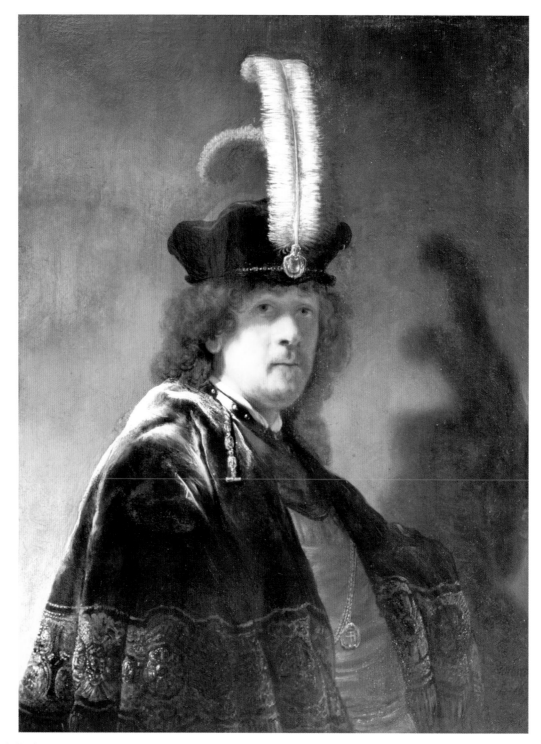

Self-portrait Wearing a White Feathered Bonnet, 1635
Oil on poplar, 91.2 x 71.9 cm (36 x 28⅓ in)
• Buckland Abbey, Devon

This high-quality work was at one time attributed to Govaert Flinck. It has also been considered a copy but X-ray research has shown that changes were made to its composition, so this is not likely.

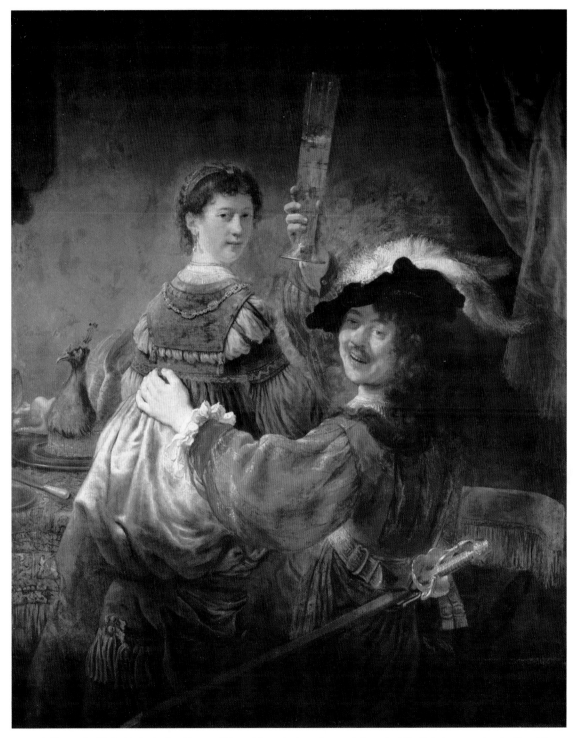

**Self-portrait with Saskia in the Parable
of the Prodigal Son,** *c.* **1635**
Oil on canvas, 161 x 131 cm (63²/₅ x 51²/₃ in)
• Gemäldegalerie Alte Meister, Dresden

This work has raised questions as to its content. Saskia looks reserved and polite, while
the man looks raucous and inebriated. This scene appears to be taking place in a brothel;
a 'madam' in between the pair was later painted out.

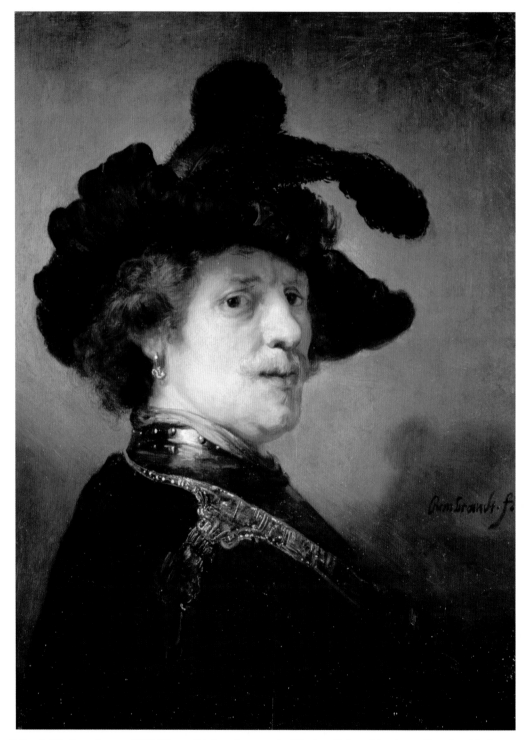

Self-portrait in Fancy Dress, *c.* **1635–36**
Oil on canvas, 62 x 47 cm (24²/₃ x 18¹/₂ in)
• Mauritshuis, The Hague

This is another example of Rembrandt's love of dressing up. The rather ridiculous hat and Rembrandt's expression, with pursed lips and laughing eyes, create a comic theatrical effect.

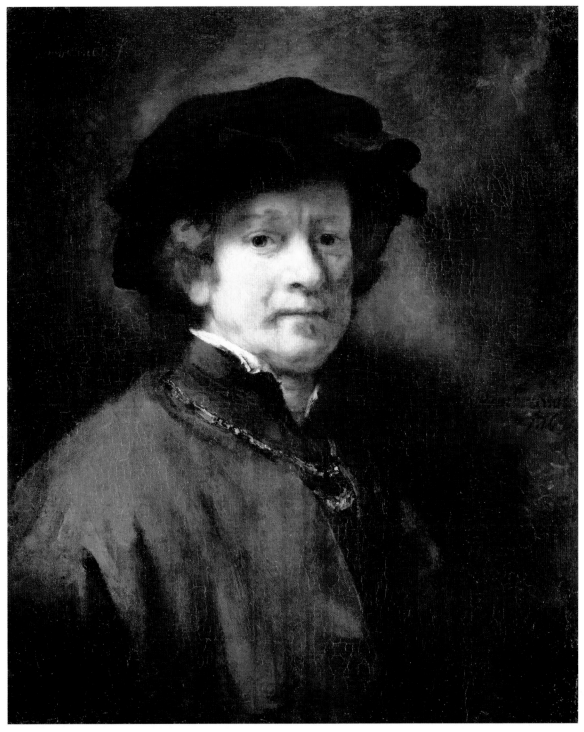

Self-portrait with Cap and Gold Chain, 1654
Oil on canvas, 72.5 x 59.3 cm (28$\frac{1}{2}$ x 23$\frac{1}{3}$ in)
• Gemäldegalerie Alte Meister, Kassel

This half-length portrait gives the viewer the impression of a quiet, contented man. The black cap and chain give him a distinguished air, and his face and eyes, together with a faint smile create a sympathetic impression.

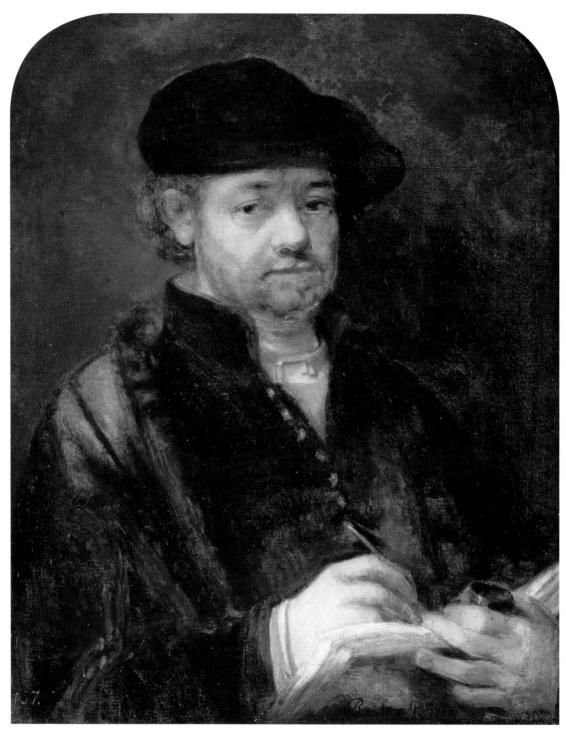

Self-portrait with Sketch Pad, 1657
Oil on canvas on board, 85.5 x 65 cm (33³/₄ x 25²/₃ in)
• Gemäldegalerie Alte Meister, Dresden

Rembrandt holds the tools of his trade comfortably, as if they are an extension of himself. He looks out of the portrait directly at the viewer. Is it us, his viewing public, that he is sketching?

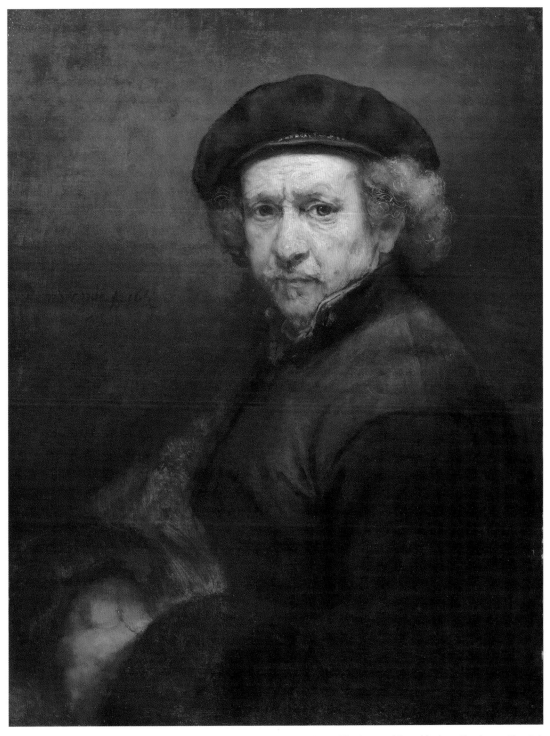

Self-portrait, 1659

Oil on canvas, 84.5 x 66 (33¹/₃ x 26 in)

• National Gallery of Art, Washington D.C.

Rembrandt has lived through the difficult years of financial ruin and insolvency. The strain and opprobrium of others have taken their toll. He looks resigned, worn and perhaps also a little angry.

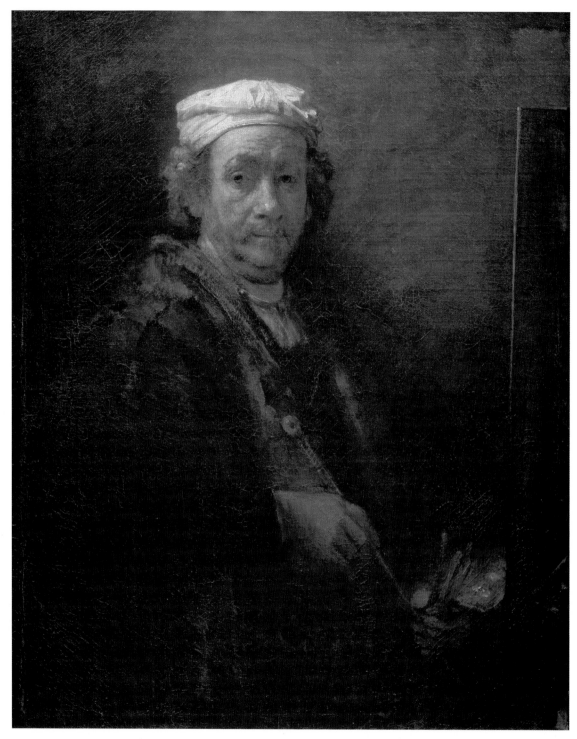

Portrait of the Artist at his Easel, 1660
Oil on canvas, 111 x 85 cm (43³⁄₄ x 33¹⁄₂ in) • Louvre, Paris

We see here Rembrandt once more with the tools of his profession. Despite all his troubles, he continued to paint; his art and profession were always there for him.

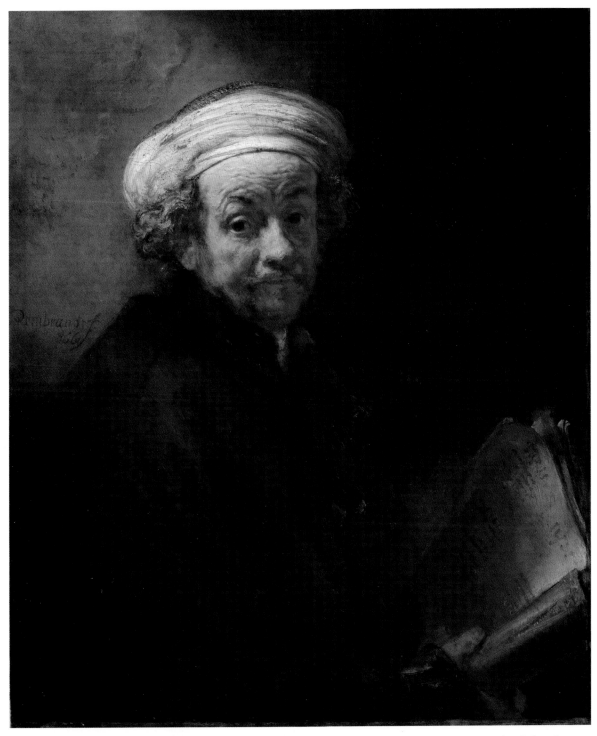

Self-portrait as the Apostle Paul, 1661
Oil on canvas, 91 x 77 cm (35⁴/₅ x 30¹/₃ in)
• Rijksmuseum, Amsterdam

Paul suffered much persecution and many trials, and yet he persevered to win through. Rembrandt may well have been comparing himself to the great apostle, identifying with him in tribulations and the need for strength to overcome them.

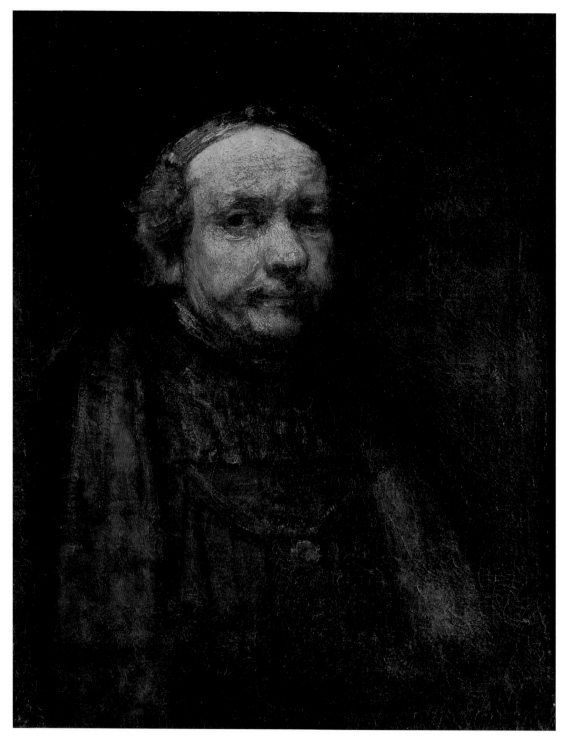

Self-portrait as an Old Man, 1664
Oil on canvas, 74 x 55 cm (29 x 21²/₃ in) • Galleria degli Uffizi

Rembrandt's expression is one of world-weariness. He looks as if the changing circumstances of his earthly lot have worn him down. There is little to lighten the overall effect of darkness.

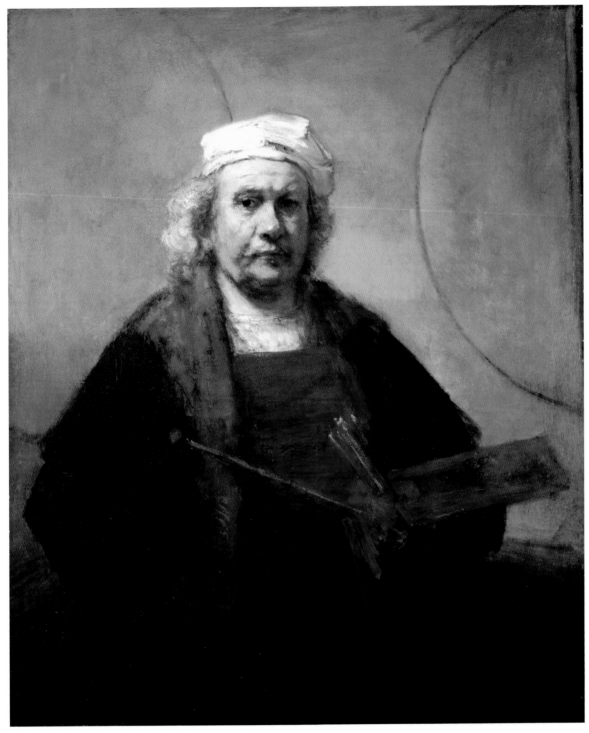

Self-portrait, c. 1665
Oil on canvas, 51.8 x 42.7 cm (20²/₅ x 16⁴/₅ in)
• The Iveagh Bequest, Kenwood House, London

Wearing his white artist's cap, and carrying his palette and brushes, Rembrandt looks out steadfastly at the viewer. The meaning of the two circles on the wall behind has been widely debated.

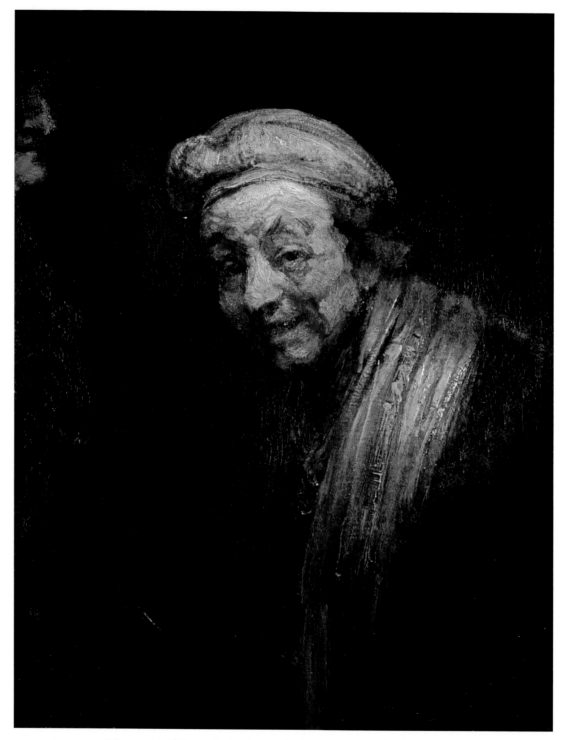

Self-portrait, _c._ 1668
Oil on canvas, 82.5 x 65 cm (32¹/₂ x 25²/₃ in)
• Wallraf-Richartz Museum, Cologne

The Greek painter Zeuxis – who some argue Rembrandt is posing as here – reportedly died laughing at his own portrait of an old woman. Rembrandt leans forward towards the viewer, while a shadowy figure lurks in the corner behind him.

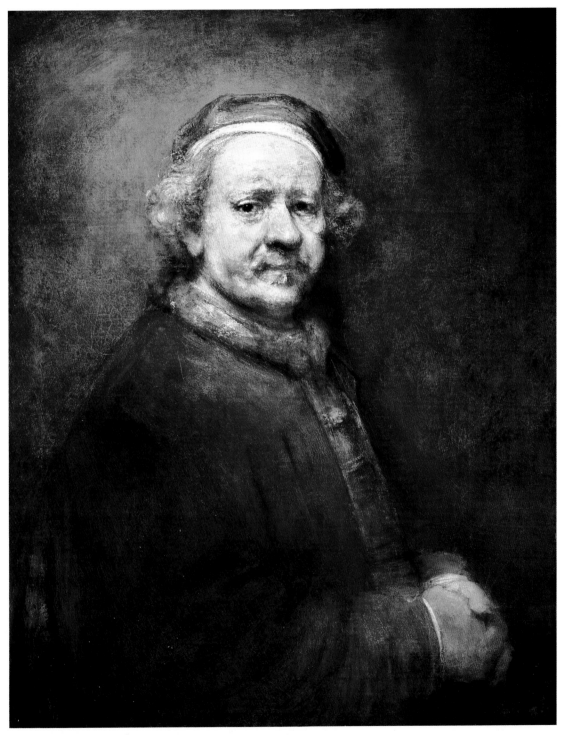

Self-portrait at the age of 63, 1669
Oil on canvas, 86 x 70.5 cm (34 x 27⁴/₅ in) • National Gallery, London

Rembrandt looks proud and dignified in a rich red robe and hat, with his hands folded in front of him in a calm and composed manner. In his final year he painted three self-portraits.

Etchings
& Drawings

Etchings and drawings gave
Rembrandt the opportunity to
experiment with black and white,
and shades of dark and light. They
also provided a means of researching
and developing his treatment
of the human figure and the
natural landscape.

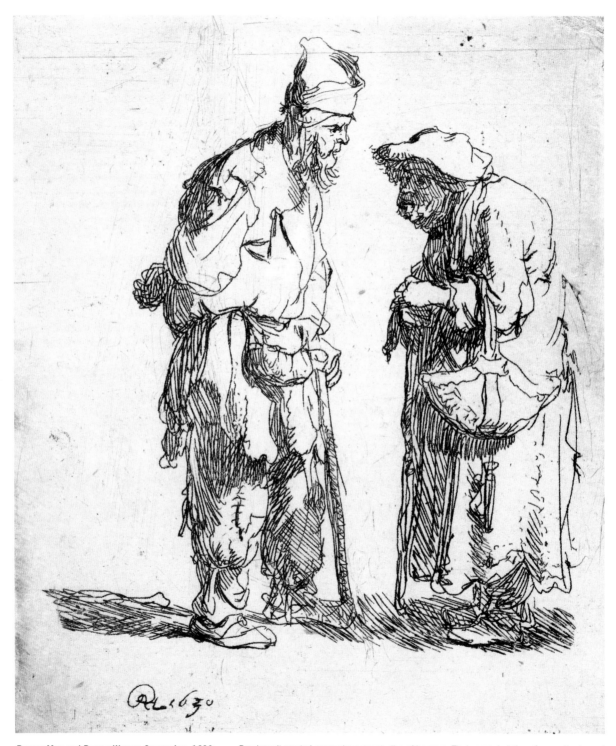

Beggar Man and Beggar Woman Conversing, 1630
Etching, 7.8 x 6.5 cm (3 x 2²/₃ in)
• Ashmolean Museum, University of Oxford

Rembrandt created many character studies of beggars. Their ragged clothes, frequently stooped posture and worn faces provided challenging material for the development of artistic skills.

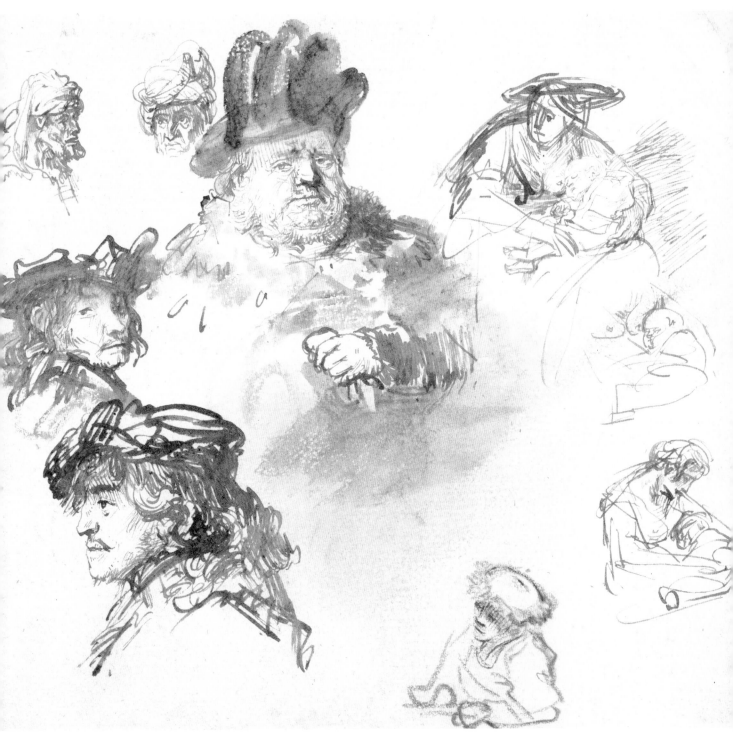

**Studies of Old Men's Heads and Three
Women with Children,** *c.* **1635-36**

Ink and wash on paper, 22 x 23.3 cm (8³⁄₄ x 9¹⁄₄ in)

• The Barber Institute of Fine Arts, University of Birmingham

This sheet of studies gives some idea of how Rembrandt would sketch out ideas and
experiment in developing them. The images range from slight sketches to detailed depictions.

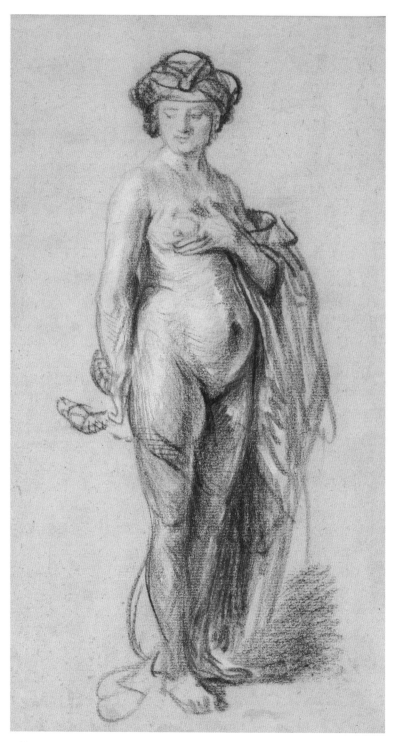

Nude Woman with a Snake, *c.* 1637
Red and white chalk on paper, 24.7 x 13.7 cm (9³/₄ x 5²/₅ in)
• J. Paul Getty Museum, Los Angeles

Rembrandt classified his drawings into groups and kept them in separate portfolios.
Few of them are signed and this has made attribution difficult. Here Cleopatra possibly
provided the theme for a study of the female nude.

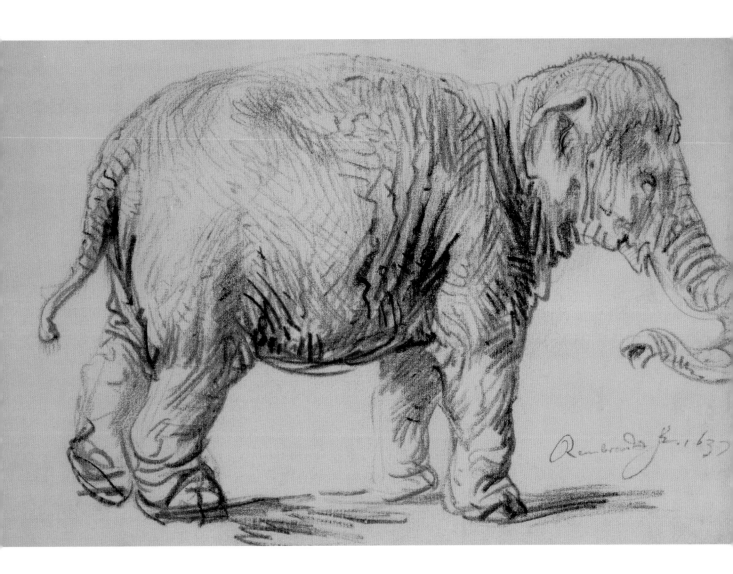

An Elephant, 1637
Charcoal on paper, 23.3 x 35.4 cm (9¼ x 14 in)
• Grafische Sammlung Albertina, Vienna

Amsterdam was the centre of a large empire, and its port saw many and varied people and animals. The elephant has a characterful face; it lifts its back foot and waves its trunk.

Birds, c. 1637
Pen and ink and wash on paper (b/w photo), 18.1 x 15.4 cm (7 x 6 in)
• Musée Bonnat, Bayonne

Rembrandt continues to challenge himself to develop his skills in all areas of his art. This study is notable for the elegant lines and delicate traces of movement in the beautiful long tails of the two birds.

Sleeping Watchdog, c. 1637–40
Pen and ink with wash and opaque white w/c on paper,
14.3 x 16.8 cm (5²/₃ x 6²/₃ in) • Museum of Fine Arts, Boston

This drawing conveys the sinuous line of the curled-up dog as he sleeps in his kennel.
With a few pen marks Rembrandt creates the light and shade of the kennel's surroundings.

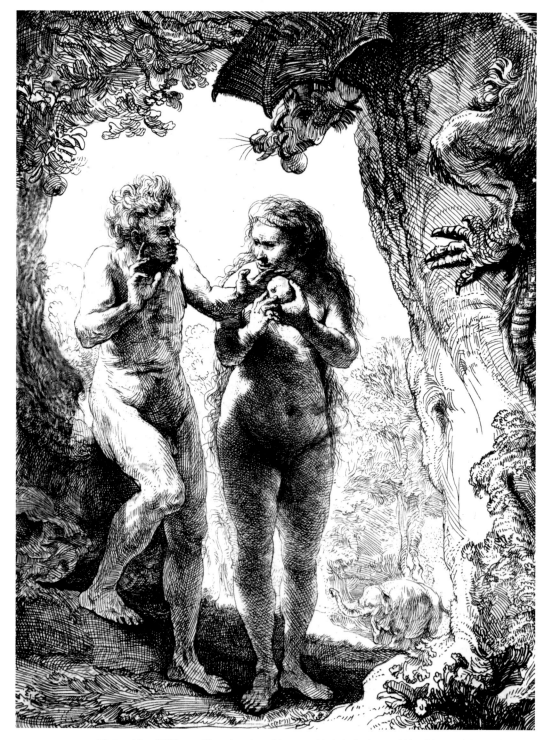

Adam and Eve, 1638
Etching, 16.4 x 11.5 cm (6½ x 4½ in) • Private Collection

The ugly and repulsive serpent lurks in the tree, watching Adam and Eve eat the forbidden fruit. In the background an elephant wanders through the Garden of Eden.

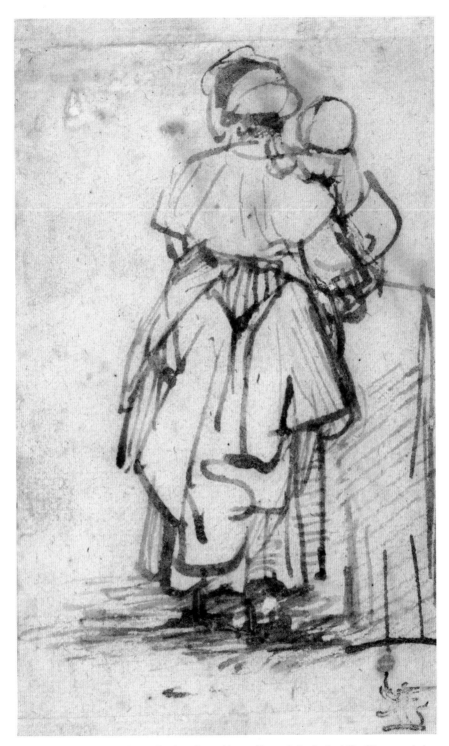

Woman with a Child on her Lap, *c.* 1640
Pen, ink and pencil on paper, 40.2 x 25 cm (15⁴/₅ x 9⁴/₅ in)
• Pushkin Museum, Moscow

Rembrandt uses his pencil to create the flowing folds of the woman's dress and cloak with economy of expression. The weight of the child in her arm is counterbalanced by the turn of her head.

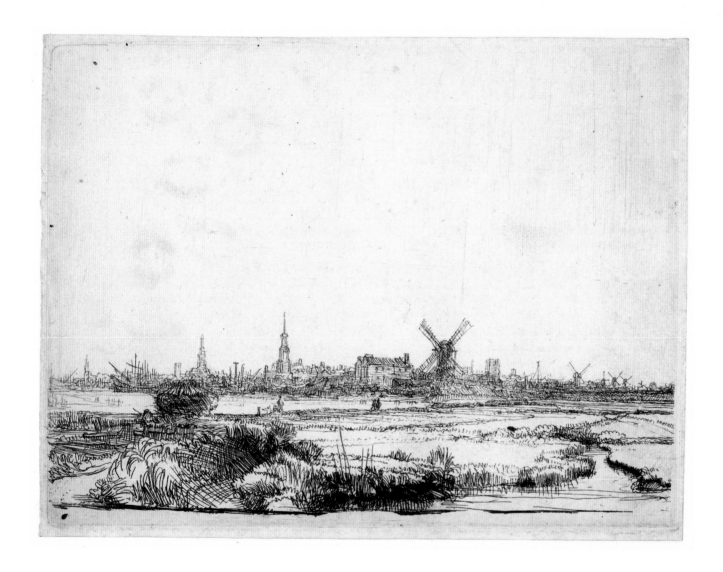

View of Amsterdam, *c.* 1640
Etching, 11.1 x 15.1 cm (4²/₅ x 6 in)
• UCL Art Museum, University College, London

This etching – with its vast sky punctuated by windmills and church spirals, and its foreground of water, reeds and marshland – evokes the spacious hinterland and the crowded centre of the city.

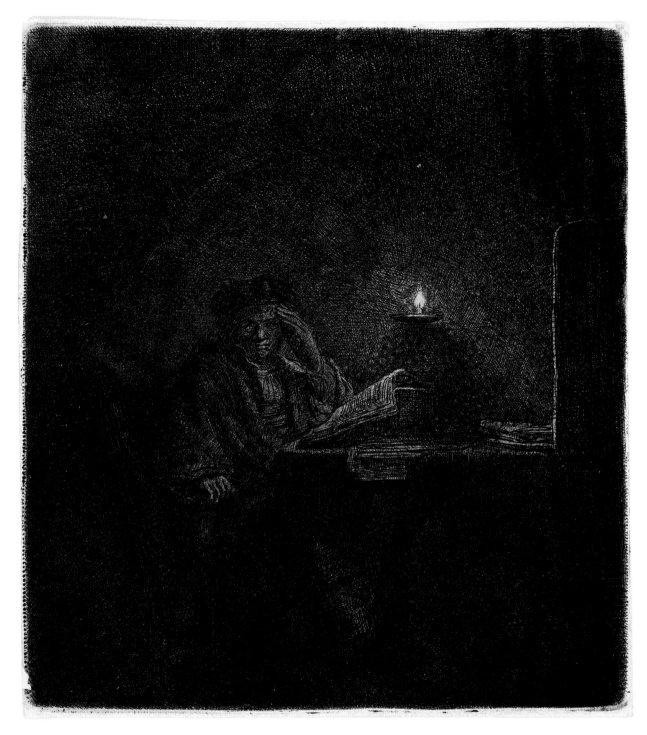

Student at a Table by Candlelight, *c.* **1642**
Etching, 14.9 x 13.5 cm (6 x 5⅓ in) • Museum of Fine Arts, Boston

The student, with his hand to his head, peers out at the viewer through the darkness. The candle flickers, casting its light on the book propped up on the table.

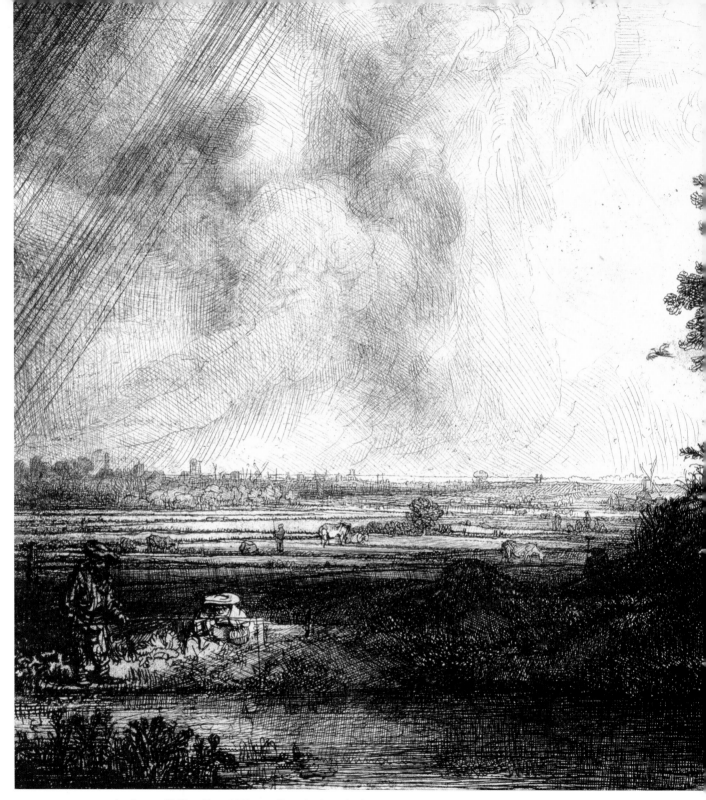

Landscape with Three Trees, 1643
Engraving and etching, 21.3 x 27.9 cm (8²/₅ x 11 in)
• Fitzwilliam Museum, University of Cambridge

Storm clouds are clearing away and the sun is breaking through, illuminating three trees
on the hillside. These have been thought to represent the three crosses at the time of
Christ's crucifixion.

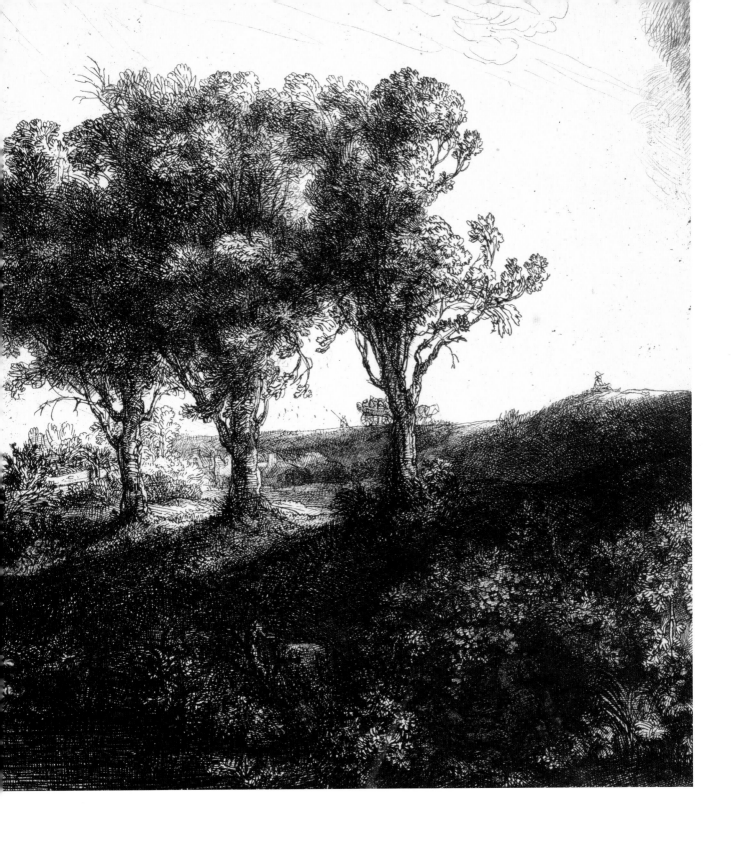

The Holy Family Sleeping, with Angels, 1645
Pen and ink with gouache on paper, 17.3 x 21.2 cm (6⁴/₅ x 8¹/₃ in)
• Fitzwilliam Museum, University of Cambridge

Mary, Joseph and the infant Jesus in his cradle are taking a rest, while angels overhead protect them from harm. It is thought that this drawing is related to the painting in the Hermitage, St Petersburg.

Man Seated on the Ground, 1646
Etching, Private Collection

The man turns his head away from the viewer, who can then appreciate his luxuriant hair, each strand delicately etched by Rembrandt. Light and dark interplay to create pools of shadow.

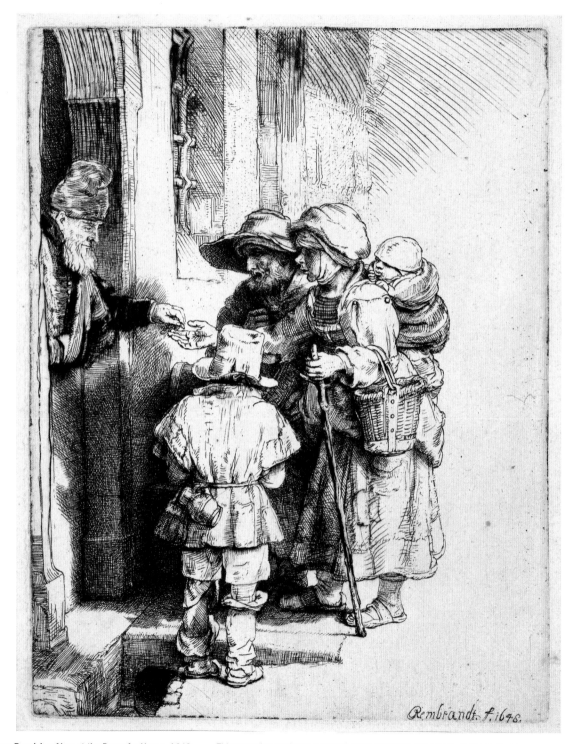

Beggars Receiving Alms at the Door of a House, 1648
Drypoint engraving, 16.5 x 12.9 cm (6½ x 5 in)
• Fitzwilliam Museum, University of Cambridge

This engraving produces in minute detail every line and crease on the beggars'
clothes. The owner of the house who has a kindly face and is well dressed, hands
over a gift to them.

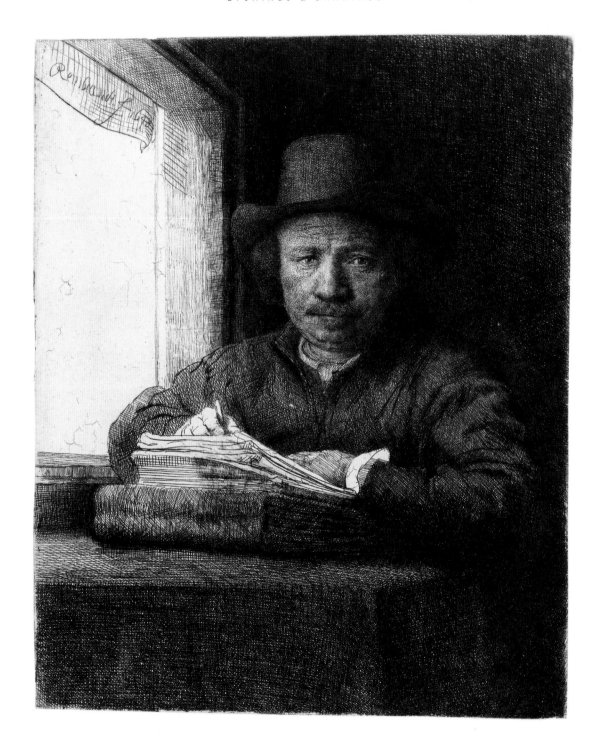

Self-portrait Drawing at the Window, 1648
Etching, 16 x 13 cm (6¹/₃ x 5 in) • Rijksmuseum, Amsterdam

The light from the window illuminates Rembrandt's face and his book. He is wearing his everyday clothing and has a serious, almost grave, expression as he gazes directly at the viewer.

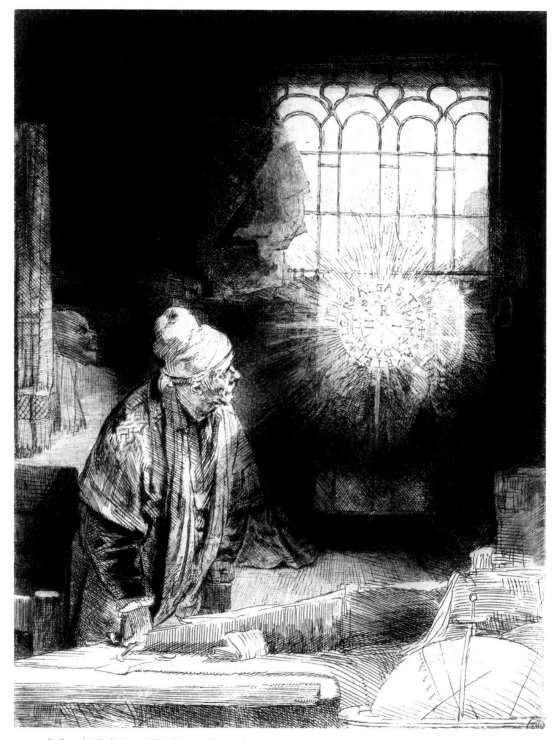

Dr Faust in His Study, *c.* **1652–53**
Etching, 20.9 x 16.1 cm (8¼ x 6⅓ in)
• Leeds Museums and Galleries (Leeds Art Gallery)

The scholar working in his study is amazed by the shining disc of light by the window.
In its centre, the letters INRI recall the inscription put over Christ's head at the crucifixion.

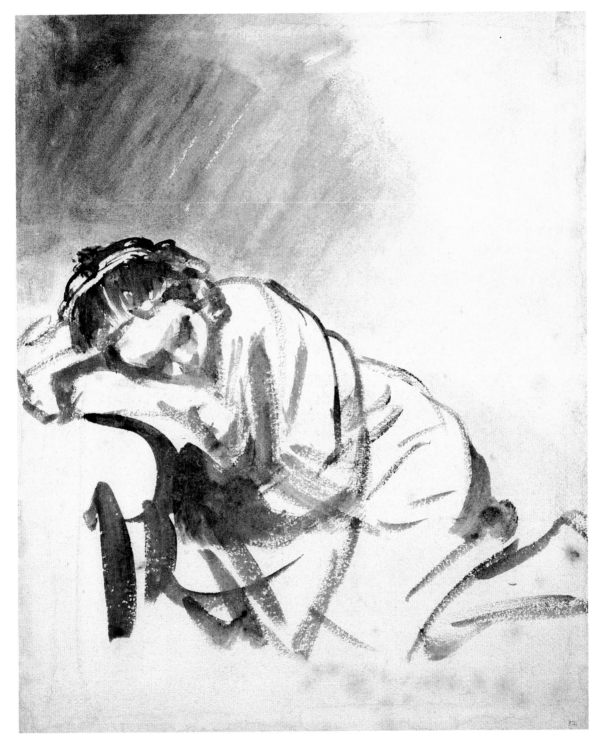

A Young Woman Sleeping (Hendrickje Stoffels), c. 1654
Brush and brown wash on paper, 24.6 x 20.3 cm (9²/₃ x 8 in)
• British Museum, London

With a few sparing lines, Rembrandt creates this image of a young woman, possibly Hendrickje Stoffels, as she takes a rest while leaning her head on her arm. A little background shading completes this vignette.

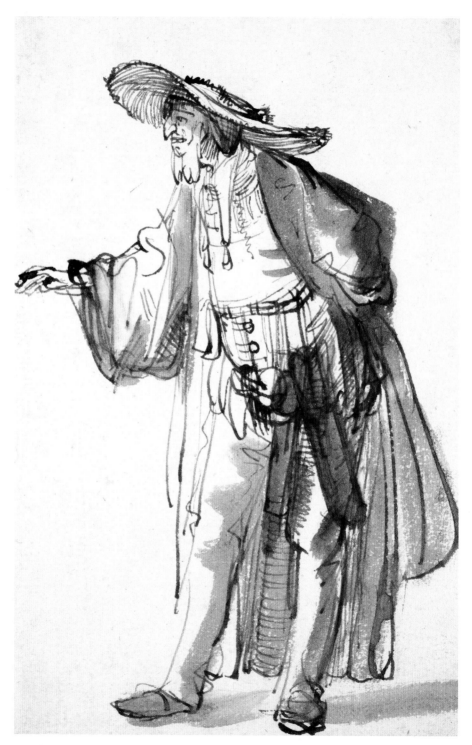

Actor with a Broad-rimmed Hat, 17th century
Pen and ink and wash on paper, 18.2 x 11.8 cm (7¼ x 4⅔ in)
• Hamburger Kunsthalle, Hamburg

This work reflects Rembrandt's interest in the theatre; he created a series of drawings of actors. This exuberantly dressed character reaches forward with one hand, while drawing back his coat with the other hand.

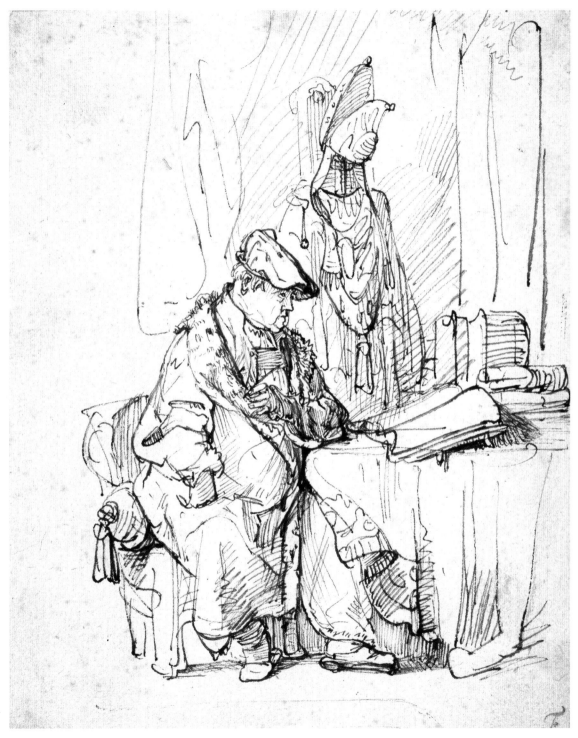

An Actor in His Dressing Room, 17th century
Pen and brown ink on paper, 18.3 x 15 cm (7¼ x 6 in)
• Chatsworth House, Derbyshire

A portly actor sits surrounded by the paraphernalia of costumes and props in his dressing room. Dressed in his stage clothes and peering at a large book, he is perhaps going over his lines.

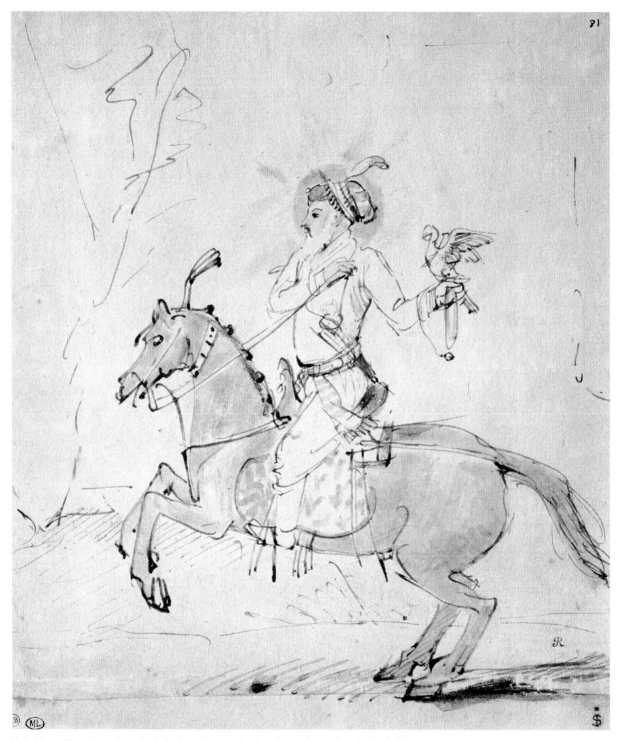

Shah Jehan with Falcon on Horseback, 17th century
Pen and ink and watercolour on paper • Louvre, Paris

Rembrandt owned a number of works by Persian artists. Here he experiments with a Persian style of line, as he depicts Shah Jehan on horseback with a falcon on his wrist.

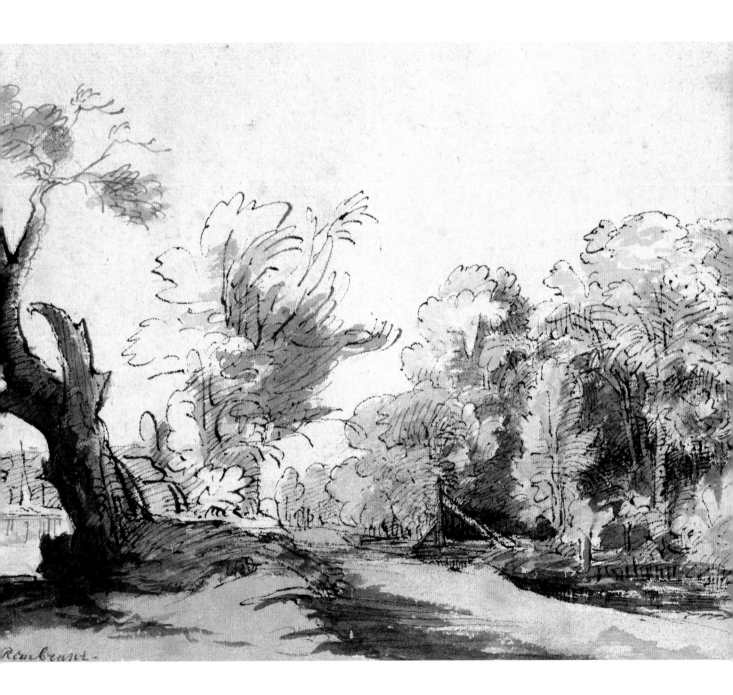

Landscape with a Path, an almost Dead Tree on the Left, 17th century
Pen, ink and wash on paper, 12.5 x 15.9 cm (5 x 6⅓ in)
• Hamburger Kunsthalle, Hamburg

The almost dead tree provides a pool of dark shadow on the left which is balanced by the lighter swirls and shading of the other trees depicted. The path winds into the distance, creating a sense of depth.

Indexes

Index of Works

General Index

Masterpieces of Art
FLAME TREE PUBLISHING

A new series of carefully curated print and digital books covering the world's greatest art, artists and art movements.